DREAMING OF RAMADI IN DETROIT

Also by Aisha Sabatini Sloan

Captioning the Archives
Borealis
The Fluency of Light

DREAMING OF RAMADI IN DETROIT

Essays

REVISED EDITION

Aisha Sabatini Sloan

Graywolf Press

Originally published in a different form by 1913 Press in 2017

Epigraph used with the permission of Pope.L.

This publication is made possible, in part, by the voters of Minnesota through a Minnesota State Arts Board Operating Support grant, thanks to a legislative appropriation from the arts and cultural heritage fund. Significant support has also been provided by other generous contributions from foundations, corporations, and individuals. To these organizations and individuals we offer our heartfelt thanks.

MINNESOTA
STATE ARTS BOARD

CLEAN
WATER
LAND &
LEGACY
AMENDMENT

Published by Graywolf Press
212 Third Avenue North, Suite 485
Minneapolis, Minnesota 55401

www.graywolfpress.org

Published in the United States of America

ISBN 978-1-64445-271-4 (paperback)
ISBN 978-1-64445-272-1 (ebook)

2 4 6 8 9 7 5 3 1
First Graywolf Printing, 2024

Library of Congress Control Number: 2023940234

Cover design: Frances Baca

Cover art: Leigh Wells

For Argusta

Always two sides to every question.
But what's the fucking question?
I didn't hear it?
Does it peel away like an onion?
On and on and on until there's nothing?
Does it melt like ice until it's some kind of invisible something?

—POPE.L

Contents

DREAMING OF RAMADI IN DETROIT

A Clear Presence

When I was in junior high school, my mother and I heard the sound of helicopters while we were house-sitting for friends in the Hancock Park neighborhood of Los Angeles. We had just come in from using the swimming pool when someone on a megaphone instructed us to come outside with our hands up. When we did, policemen were facing the house with guns pointing toward the door, neighbors were standing on their porches in alarm, and a helicopter was hovering overhead. Our dog ran outside, and we squealed with terror that they shouldn't shoot her. It turned out that we had accidentally triggered the security system's distress signal, and it took a while for them to determine that we were not being taken hostage. But the incident was, in some ways, an elaborate confirmation of a feeling that I held already, about that house and the city in general: that even though we had permission to be there, we had somehow managed to trespass.

When he was a young man, the Olympic diver Sammy Lee was allowed to use the public pool only on a certain day in the week reserved for people of color. After that day, the pool was drained and refilled for the comfort of the white patrons. My father remembers hearing, during an interview with Lee, that the diver returned years later, after his win, and confronted the people who maintained the

pool to ask why they felt the need to drain it—as if his Korean background and the black skin of his friend had somehow infected the water. They told him that, to the contrary, they always considered the order ludicrous. Rather than draining the pool as they'd been told, they would lock the doors for a couple of hours and add a little extra chlorine to satiate the people in charge. But the fact of Lee's exclusion, the lie of his body being a contaminant, had already influenced his understanding of the world.

In a recurring dream, I am swimming in somebody else's pool. The city is always Los Angeles, the grounds are always well maintained, there is often a flourishing garden filled with climbing vines of jasmine, bougainvillea, and bird-of-paradise. The house to which the pool belongs is empty. I might get out of the water to wander around, always with the sense that, while I've been invited, I am not supposed to be there.

●

In his book on lucid dreaming, B. Alan Wallace writes that the dreamer can prepare to "awaken" in his sleep by following the Buddhist practice of shamatha before bedtime: "The mind's distractions are stilled so that one's attention can eventually rest comfortably and effortlessly on a chosen object for hours on end." In an attempt to cultivate this ability, I stare at a coffee cup on the table in front of me. I feel flickers of that sensation I used to know well as a child—when I could look at a truck parked on the street outside of our apartment and feel that the world radiated out in all directions, that infinity existed inside of each scene and every second, like the sound of wind or falling water.

Once, at a museum in London, I saw a set of portraits by the painter David Hockney. Everyone portrayed in that particular series worked as a docent in a museum. Hockney sometimes uses a roller in his

paintings, so that the shape and shadow that realistically depict a nose or chin float inside a stilled space that has been divorced from the rippling pulse of passing time.

If, as curators have demonstrated, you look at the Polaroid image that was used as a reference for the portrait that Hockney would later create, you can see the way that he brings the friends he paints into a new realm by stripping away the subtlest of layers, creating a dimension that is at once matte and luminous, breathing and flat. And, though I've only had a handful of lucid dreams myself, I wonder if Hockney's realm isn't just the quiet landscape of a lucid dream. A distillation and capture of that intangible state of being that we have talked to death, can't possibly bear to utter again, but still seem desperate to enter. Through his brush, the present moment becomes a kind of shoebox diorama inside which the viewer can wander, take refuge and maybe a nap.

Though he made much of his work in a studio just large enough to fit his giant canvases, Hockney helped to establish what Christopher Simon Sykes describes as an "image of California as a carefree land of sunshine, affluence, and leisure" by painting its wealthiest citizens and their swimming pools. But while presenting California as an idle playground for the rich, Hockney also engaged with a meditation not unlike shamatha, devoting himself to the task of rendering water with a diligence of spirit that he himself compared to Leonardo da Vinci's. This meditation involved grappling with the essence of movement and time. He studied the way that sunlight manifested itself through dancing lines of light, explaining: "Water in a swimming pool is different from, say, water in the river, which is mostly a reflection because the water isn't clear. A swimming pool has clarity. The water is transparent and drawing transparency is an interesting graphic problem."

●

Rodney King was swimming on the first day he ever heard the word *nigger*. His small self popped out of the water only to dodge a fast-passing stone: "Run, nigger!" It was the first time he realized that he wasn't just a kid; he was a Black kid. Despite the life he would live thereafter, King writes that it was "the saddest day in creation for me." He wishes he could "find a way of forever removing that day from every Black child's life."

As I was growing up, African-inspired names were pronounced to elicit humor. People liked to exaggerate the *y* sound, the *e* sounds, the funky *q* pronounced with a flip of the head and a series of snaps. As one of the only people of color in my school, I hated to have my difference pointed out to me, and got famously angry any time someone pronounced my name with three syllables (*ay-ee-sha*) instead of the two (*ee-sha*) that my parents had used since I was born. The former pronunciation of my name was featured in "Iesha" by Another Bad Creation, and my classmates were not about to let me forget it. Whenever somebody wanted to laugh, they could sing the chorus, and I would explode into what I did not realize at the time was a vaguely self-hating rage.

During a game of "ga-ga" one afternoon, I responded to the taunting by slapping the singer, a girl with whom I was both friends and bitter enemies, on the back. She responded in kind, until we were engaged in a full-out brawl, to the entertainment of everyone in the auditorium. We began to giggle soon after the after-school director pulled us apart, but the incident cemented my reputation as an easily coaxed spitfire, ready to face off with anyone who dared call attention to my membership to *that* Blackness, the one that was in the process of being celebrated or objectified, depending on the viewer, through shows like *Martin* and *In Living Color*.

I grew up in an apartment building two blocks away from where Nicole Brown Simpson was nearly decapitated alongside Ron Goldman, who worked in a restaurant up the hill from our home.

My mother and her friend passed by Simpson's condominium on an evening stroll about an hour before the murders were committed. Perhaps because the only known Black male resident of this neighborhood was O. J. Simpson, the community has for as long as I can remember acted toward my father and me as though we wandered into the place by accident. If I was wearing a thick coat or heavy sweatshirt, adults would cross the street to avoid me while I was walking my dog at night. Women held their purses tighter when my father stood behind them at the bank, and he was frequently approached by patrolmen, accused of "looking like you don't belong" while walking in a sweat suit through his own garage.

Recently, while I was walking on the sidewalk, I trailed behind an African American man who was pushing a cart of his belongings down the middle of the street, his back sloped nearly parallel to the ground. I grew nervous when a car started to drive quickly up the road behind him without seeming to know he was there. The driver of this car was Black. Up ahead, I heard a second car swerve quickly, and somebody beeped. As the white driver of this other car drove from the opposite direction, I could hear him shout out his open window, "Get the fuck out of Brentwood."

Whether he was talking about the houseless man or the driver who swerved around him, I felt strangely relieved by the outburst, as if the source of my discomfort in this neighborhood was finally being spoken out loud.

Of the night of his beating, King writes in his autobiography: "I could smell the hatred, it was a clear presence."

◆

In 1978, David Hockney began work on a series entitled *Paper Pools*, including twenty-nine color pictures created by pressing paper pulp.

As Nikos Stangos writes, the project allowed him to bring together "many of the themes he most loves: the paradox of freezing in a still image what is never still, water, the swimming pool, this man-made container of nature, set in nature which it reflects, the play of light on water, the dematerialized diver's figure under water." Hockney recalls, "As the time had gone on and the sun wasn't coming out as much now and the days were cloudy, the water began to look a bit different and the tones were all-over blue. It rained and when it rained the steps started with a deep blue at the top and the blue faded as the water got more opaque because of the rain, and I thought the water looked wetter, it was all wet, now it was all about wetness."

In one Polaroid picture that Hockney used as inspiration for an image entitled *Pool with Cloud Reflections*, the water is nearly indistinguishable from the sky it reflects. The clean-lined shadow of a building amplifies the bright lines of an overhead cloud, making it difficult to know whether the sky is being reflected on the water or, through the trick of glass and shadow, water is being reflected onto the sky. The picture encapsulates what must have drawn Hockney to return, time and time again, to this particular subject: "Depending on the weather, whether it was cloudy or sunny—each day was different—you could look right through it, into it, onto it."

Though they might not perceive it while underwater, a swimmer in such a scene would seem to be moving through two realms at once: gliding, weightless, through the water, and at the same time moving through those darkening clouds, their edges set aglow by the same sun deepening the shadow of the surrounding trees. The image calls to mind the web of emotions I swam through while dreaming, again, of pools last night. This time, I did so with a former lover whose absence still makes me nauseous. Reentering, through dream, the confines of a relationship that just ended, it is like I am moving through two elements at once, water and air, two states of being—occupying a self that has not yet had to grieve the loss.

In the dreams I've had of pools in the past, I remember craving the house nearby. I feel a sense of separation from the very notion of a home. Even if I were able to walk inside, feet leaving a trail of puddles behind me, I would not be able to *know* it: the comfort of having arrived constantly eludes me.

According to B. Alan Wallace, the lucid dreamer is given an opportunity. You come upon an old fear and may "be able to confront that fear lucidly in your dreams—repeatedly—and overcome it. For example, you may forgive and be forgiven by placing yourself in a replica of an original situation that traumatized you or caused you embarrassment. By revisiting it, you may accept and integrate a situation that occurred years ago but is still disturbing you."

Before he died, Rodney King took part in a reality-TV show on VH1 in which celebrity guests moved in together as they went through rehab under the guidance of Dr. Drew Pinsky. King had been a lifelong alcoholic, and his own drunkenness on the day he led the police on a car chase contributed to his feelings of guilt, as though perhaps he deserved to have been beaten to a pulp. Dr. Drew tells him that he is sorry for the way King was treated. King writes, "I never get tired of hearing that I didn't deserve what those police did to me."

For the purposes of the show, King was taken to the site of the beating. "I looked around and just took everything in," he writes. "It was a day that couldn't decide whether it wanted to be cloudy or sunny, and I remember feeling kind of hazy myself about whatever we were planning to do next. But Dr. Drew kept saying this was a good way to get closure on the whole ordeal, and I definitely felt that seventeen years was a long enough time to be tormented and unresolved. . . . As we lingered there for a few moments, all the conflicting feelings inside me, all that rage kind of took a breath, quieted down enough for me to ask: 'Okay, Rodney, now what are

you going to do here? Not for the cameras, but for yourself . . . make this true, make this count.'"

When he returned home after the show ended, clearheaded and optimistic, he returned to a mess: "There was a toilet seat out back and an empty pool with gunk in it."

In an image called *Green Pool with Diving Board and Shadow*, the world around Hockney's pool has a nightmarish feel, blackness interspersed with what look to be bright red shrubs. As though an apocalypse were flaming outside the confines of the pool.

♦

On a recent afternoon, I stood at the sink. For some reason the hot-water stream was especially thin, and I was listening to a story about an explosion in Damascus. It occurred to me that water is a resource, that riots are about resources. And I felt perilously close to the way the pending water crisis would resolve itself socially, politically.

After the police who beat him were acquitted in 1992, before the LA riots began to unfold around him, Rodney King and his family sat on tattered lawn furniture in the yard. A signal flare shot out through the sky over South Central. One of his cousins drove up to the house and began to unload boxes of stolen diapers, food, and liquor, charred from a fire.

As they began to perceive what was happening, King "went up to the attic and grabbed an old Bob Marley wig we used to keep around for Halloween. You could never tell it was me with all them dreadlocks hanging down." But after nearing the scene, he had to stop. "I sensed that terrible presence of hatred that I felt the night of the beating, that palpable wall of loathing that was absolutely suffocating. I mean there were sounds like I never heard before, like

evil erupting. I lowered the window and heard what I thought was a high-tension wire that had snapped off from its tower and was spraying sparks all over the place." That's when he turned around and "headed the fuck out of there."

At home, he watched the news in horror. A construction worker was forcibly removed from his truck and robbed. One person "smashed his forehead open with a car stereo, another rioter tried to slice his ear off." A crowd spray-painted the man's body and genitals black.

King mentions the "hundred or so soldiers in camouflage" who were called in to bring the destruction under control, pointing out that "one of the guards admitted that they were all ill prepared and said that street duty for riots worried them more than being called up for the Gulf War."

Later in life, King explains to a reporter for the *New York Times*, "I don't want to be remembered as the person who started the riots. I'd like to be remembered for the person who threw water on the whole thing. Part of the solution, you know?"

❦

At the Los Angeles County Museum of Art, I stand behind a class of children being taught how to see a David Hockney painting of Los Angeles. "What is a landscape?" the teacher asks. A boy raises his hand and explains, "A landscape is land that is curved." The children point out that the trees at the bottom of the painting don't look like real trees. An African American boy is handed a paintbrush and asked to imagine the strokes that would have been required to create the gaping, colorful cityscape that hangs before him.

Hockney eventually tired of painting the swimming pool. In a video review of *A Bigger Picture*, Alastair Sooke walks through the exhibition

halls at the Royal Academy of Arts, describing the conventional pastoral scenes with an air of disappointment. "Here, though," he says, heartened, "you have something else. There's a very, as you can see, vivid, intense palette. . . . It has an almost religious-vision intensity." Sooke continues, "It doesn't take very long to look at that tree stump, and to look at those chopped-up logs awaiting collection, and start seeing symbols of mortality. Hockney has managed to take quite an everyday humdrum scene in Yorkshire, something really with very little mystery, and imbue it with power and strangeness." The images here are convoluted, trees are blue, pink, and yellow, and the tone is one of a brightly colored nightmare.

"Were you flying," B. Alan Wallace asks, "passing through walls, walking on water? What about odd and repeated *environments*? Do you frequently find yourself in the same dreamscape? Are the surroundings odd—blue plants, purple sky, red clouds, two suns?" If so, you can remind yourself that you are dreaming, and navigate the dream as though you were awake. "You can practice walking over tall bridges, experiencing the sense of height while simultaneously aware that it is all a dreamscape. You can jump off the bridge if you like, and you will merely float down to 'earth.'"

In February of 2013, an African American man who claimed that he had been unfairly terminated from the Los Angeles Police Department went on a rampage. He wrote out a long list of people who should expect to be targeted, and was ultimately accused of killing four people, including the daughter of a former police captain and her fiancé. What was most frightening about him was how well he knew the system that sought to catch him. He said that he knew the routes that his colleagues took to and from work, their "children's best friends and recess," even the hours when their girlfriends went to the gym. It was one of the biggest manhunts in California history. In the very lengthy manifesto he posted on Facebook, Christopher Dorner asks his reader, "Are you aware that

an officer . . . seen on the Rodney King videotape striking Mr. King multiple times with a baton on 3/3/91 is still employed by the LAPD and is now a captain on the police department?" Death, he claimed, was the only way to get anyone's attention about the inequities of a flawed system.

One of the incidents that Dorner contests in his manifesto took place during his days as a recruit. In trying to paint a portrait of Dorner as an aggressor, officers accused him of bullying a Jewish colleague. Dorner argues that it was he who stood up for the man whose father had survived a concentration camp when a group of recruits sang Nazi Hitler Youth songs "about burning Jewish ghettos in WWII Germany."

During the peak of the manhunt for Dorner, I went on a Friday-night date to the Los Angeles County Museum of Art. Dorner's face, eerily cheerful, was lit up on neon billboards all over the city, and in some ways his presence acted as a kind of secondary exhibition as we wandered through the museum. The sound of a helicopter permeated the galleries of one wing, and even after I found the source of the sound in a dark room with a projected video, I couldn't help peeking out the windows, fully anticipating a shoot-out in the museum's atrium. I peered closely at a small black-and-white photograph of what looked to be an emptied swimming pool somewhere in Southern California, in which someone had erected a paper sign that read HOLY. Later that night, my date would talk about the incongruity of Dorner's smiling face, given his crimes. "He must be in so much pain," he would say, and start to cry.

The rampage and manhunt remind me of the day my mother and I sat in a living room filled with cigarette smoke while I got my hair braided. A little girl ran in circles through the house, the woman braiding my hair acting as though we weren't actually there, despite the fact that she was touching me. The television played a movie

that I did not think I was going to be able to stomach. But, to my surprise, fifteen or so minutes into the Michael Douglas film *Falling Down*, I found myself filled with adrenaline, even laughing at points as the actor walked through the city of Los Angeles with measured gait, full of venom, attempting to right wrongs with weapons that he picked up along the way, including a rocket launcher. Our laughter seemed to say: Couldn't we all sympathize with his ennui? Weren't we all sick to death of the traffic and the bullshit? I understood even then, as a child, to feel pride about the fact that this film took place in Los Angeles. We are the city of rampages and riots! The home of the white Bronco!

On television, a male reporter sounds annoyed with his female colleague as he asks her for new information, saying her name, Gigi, over and over again. Dorner's car was last seen in Big Bear, and journalists, SWAT teams, and police officers have swarmed the San Bernardino Mountains. The news camera stands by as a group of officers searches through the trunk of a car, looking for weapons, for bodies, for Dorner. In one image, a camera mounted on a helicopter shows cabins from above, and the distortion in the video makes it look as though the snow-covered trees are pink.

The Los Angeles Police Department and the media covering the Dorner episode focus on one key point: Dorner was angry about being fired. But his manifesto makes it hard to cast his motivation as simple rejection. He writes that the weapons he is using on this rampage are the same ones that were used in Tucson, at Sandy Hook, and Aurora, and that they shouldn't be accessible to him or to anyone else. He calls the president of the NRA "vile and inhumane" and tells the Westboro Baptist Church that they can "burn slowly in a fire, not from smoke inhalation, but from the flames and only the flames." He thanks the woman he has dated over the course of his life for "great and sometimes not so great sex." He thanks his friends and tells them that he loves them. He mentions that Dave

Brubeck's "Take Five" is the best piece of music ever written. He voices his support for gay marriage, quotes Mia Farrow, and gives Bill Cosby some advice. He mentions a favorite quote of his brother's, written by D. H. Lawrence: "I never saw a wild thing feel sorry for itself. A small bird will drop frozen dead from a bough without ever feeling sorry for itself" [*sic*].

I still hear reports on the radio stating that the LAPD "found" Dorner's body in a cabin. But the event, like Dorner's motivation, was much hazier than this. In an article entitled "How Law Enforcement and Media Covered Up the Plan to Burn Christopher Dorner Alive," Max Blumenthal writes that after Dorner engaged in a shoot-out resulting in the death of an officer, "the deputies decided to burn the cabin down." A single shot was heard before the fire burned through the interior, which "may have signaled Dorner's suicide." A local TV station, KCAL 9, accidentally broadcast a deputy shouting, "Burn that fucking house down!"

On the internet later, a photograph will flash across the screen, and for a moment I won't be able to tell if what I am looking at is the meteorite that just hit Russia or the burnt remains of the cabin where Christopher Dorner's body burned.

●

As a child, Rodney King used to swim or fish with his father and brother in the irrigation canals near his grandmother's Sacramento home. "I loved the way I looked," he remembers. "The way my body sucked up the sunshine, the way my hair dried off with a shake." As an adult, he looked himself up on the internet, and found that his name had become a piece of slang: when someone has been beaten by the police, you might say he's been "Rodney King'd." He writes, "Rodney King'd? So now I've even become a verb, but when will I become a real person, a whole person?"

"On a hot, still, cloudless day," Hockney's biographer, Christopher Simon Sykes, writes, "with the sun at its highest in the sky, the heat at its most intense and the surface of the water in the swimming pool mill-pond calm, a diver has leapt from the diving board and disappeared into the depths of the pool, gone forever, his existence marked only by a violent eruption of water that is in complete contrast to the ongoing stillness of the scene."

Of taking his award-winning dive, Dr. Sammy Lee recalls, "The pool had a skylight, and when I went up to do my last dive—a forward three-and-a-half somersault—the sun broke through the clouds and I thought, 'Oh, Jesus Christ.'"

When I heard that King had died, two details in particular stuck out to me. One was that he'd died in a swimming pool. The other was that, earlier that day, somebody had heard him scream. As Anthony McCartney reports, neighbor Sandra Gardea "heard sobbing from his house earlier that morning." She said, "It sounded like someone really crying, like really deep emotions. . . . Like tired or sad, you know?"

The way Hockney describes a body in a pool is not unlike the image we've seen, time and time again, of King's face after he was beaten: "If somebody went under the water or made a splash, the splash was on the water's surface, you could look into the water and the figure was distorted." He notes, "The arms become long, the body goes odd and you begin to look like a lobster or a crab."

I tried to write an essay about David Hockney and Rodney King once before, before King passed away. While doing research, I became obsessed by a particular painting that Hockney had created of a Beverly Hills housewife. Painted one year after the Watts riots, Hockney's housewife gazes idly outside the range of the portrait. She is miles away but I want badly to imagine that she can hear the sound of sirens. I wish that she could at least smell the smoke.

"If you don't know Los Angeles," Rodney King writes, "it's hard to explain how different it is from the pictures you see on television and in movies. No pretty palm trees and manicured lawns or any of that. No fancy boutiques or pretty buildings with shiny windows. All the big houses of Beverly Hills may only be about ten miles to the north, and the beautiful beach houses on the ocean in Malibu only about ten miles to the west, but those places might as well be a million miles away."

Before he died, Anthony McCartney writes, a severely intoxicated Rodney King was seen by his girlfriend "making grunting and growling sounds and having frothy secretions coming from his mouth." While she was calling for help, "she heard a splash." By the time she got to the pool, King's body was "face down in the deep end."

While he studied the swimming pool in the process of painting *A Bigger Splash*, Hockney recalls, "what amused me was the fact that the splash only lasts a very, very short time." He explains, "A photograph can freeze it, and that's not what it's like. When you paint it, you can make it flow."

Ocean Park #6

In *Remarks on Colour*, Ludwig Wittgenstein writes, "There is no such thing as luminous gray." This seems like the best way to explain the paintings of Richard Diebenkorn: even the gray glows. My mother's best friend, Juliette, scents the house with a pot of nutmeg, spearmint, clove, and cinnamon on the stove, and collects amethyst. I think of her every time I hear wind chimes. She has skin so pale it seems to be edged by blue. When she first saw Diebenkorn's *Ocean Park* series, Juliette says, she "fell in."

In the video from my fifth birthday, you can hear Juliette's vaguely aristocratic voice cracking off-color jokes to make my dad laugh while he is filming. That was the day our dance teacher instructed us to throw a parachute into the air like a low-lying cloud, whispering as we clustered underneath the red shadow. Somewhere in that footage, Juliette's son Ramin is wandering around in a Big Bird costume, gracious amid the children and the chicken wings. For years after Ramin's death, he sat inside a cheap plastic frame near my mother's desk, his raised denim collar and movie-star good looks radiating a kind of angelic cool.

The left side of one of Diebenkorn's paintings moves through phases of blue: underlit by gray, then white.

19

"I just listened to a program about elephant songs," I tell Juliette on the phone. I describe the acoustic biologist who could feel "a throbbing in the air" near the elephant cages. A sound "below the frequency of what humans can hear." Juliette responds by talking about Mayan ruins, time travel, and the idea that Mozart could probably hear music in the air, that he could "bring that in from the ether."

Joan Didion discusses on the radio the way her writing style has shifted over time. *Bookworm* host Michael Silverblatt tells her, of *Blue Nights*, "There was an instruction process. Or like the recitation of a poem that you've come to know. You don't maybe understand the poem, but you know the rhythms that are involved here, and you complete them for yourself." She responds, "That's perfect."

> SILVERBLATT: That's what poetry does.
> DIDION: Yeah.
> SILVERBLATT: And that is, I think, what you've wanted your
> prose to do from almost the beginning.
> DIDION: I did. I mean, consciously, even. But I didn't know how
> to get there. Gradually I've learned how to get there.
> SILVERBLATT: What a price.
> DIDION: Yeah.

After Joan Didion says "yeah," the interview ends.

Blue Nights is a memoir about the death of her daughter, Quintana Roo. This is what Silverblatt means when he speaks of "a price."

In *The White Album*, years before Quintana dies, Joan Didion writes about the summer of 1968: "I remember walking barefoot all day on the worn hardwood floors of that house and I remember 'Do You Wanna Dance' on the record player, 'Do You Wanna Dance' and 'Visions of Johanna' and a song called 'Midnight Confessions.'"

In the next line, she writes, "I remember a babysitter telling me that she saw death in my aura."

Lines repeat in *Blue Nights* from early on in the book, but also from years ago. "Do You Wanna Dance?" Didion writes over and over, as if humming through the page. And of her daughter: "I still hear her crooning back to the eight-track. *I wanna dance.*"

"It becomes a wash," Juliette says, "your belief about death."

She made prayer pots at a ceramic studio called the Clayhouse: bowls with windows opening into a small purple world, at the center of which was a small patch of amethyst or the tiny figurine of a bear. She was buying "garanimals" for her son when she bumped into a woman she knew from work. The five-year-old's face was already the kind of beauty that makes a cracking sound. Though marked, the woman would point out, by a blue line "between his eye bones and his nose." She called Juliette later to explain the meaning of the vein. Her own child had died young, she explained. He'd had that vein too.

At another time, Juliette went to see a psychic, a man with cats, "who shook." Like the woman she'd seen in a department store, he told her that her son was going to die before he became an adult. "I held my breath until he turned nineteen," she says. "Most people have memory threads that we can remember of our lives, from the time that we were young on. I have this instead of a thread: barbed wire. Oftentimes that barbed wire became electrified with fear."

When I read the words *do you wanna dance*, I hear the Bette Midler version of the song, a drawn-out, nostalgic plea. Which reminds me of the film *Beaches*, which reminds me of my mother's relationship to Juliette. Two women who have been through everything together, laughing on the beach, one of them dying.

●

When Richard Diebenkorn visited Albuquerque, he flew. Everything about his approach to painting seemed to change after he looked out the window of the plane. He saw the landscape from above. In one of his works on paper, created between 1974 and 1975, composed of acrylic, charcoal, graphite, and pasted paper, there is a diagonal line stretching from one side to the other. I wonder what would happen if you used his paintings as a map, walked down those lines like streets. What threshold they'd carry you toward.

I was on my way to find his studio when I heard on the news that a man had used a semiautomatic weapon to shoot people at Santa Monica College. Not far from an intersection I'd turned down the day before. The shooter set fire to his family's home, then ordered a motorist to drive him to the school. On the radio, a man with an accent like Werner Herzog's described the moment when the man in black looked him in the eye before shooting through his windshield.

Critics warn us not to read Diebenkorn's *Ocean Park* series as landscapes, but it's hard not to wonder. Do the four dots on *Ocean Park #79* demarcate places where the bodies would one day fall? Some lines have been erased or painted over. Some lines are a blue line.

Sometimes he painted on cigar boxes. *Cigar Box Lid #5* reminds me of stained glass, the upward-facing triangles vaguely holy. The color is not so much yellow as it is white infused by brown. Lit by it. "Brown light," Wittgenstein writes. "Suppose someone were to suggest that a traffic light be brown."

A woman from the Getty Museum says of Diebenkorn's work, "I see them as altarpieces in a sense, from which the idea of a figure, a

saint, a person has been evacuated. So you have this zone, this play, this field that is surrounding you. It's almost as if you are walking into or being embraced by an abstract altar."

♦

For a while, Juliette thought that she had only months to live. She invited my mother and me into her guest room to listen to the song she wanted played at her funeral. "I'll save it for you, here," she said, bookmarking the web page. Her sense of humor is what my father calls "sick." For many years she was a caretaker for a house she referred to as "the dead man's house." My parents helped her sort through the former inhabitant's belongings, so we are now in possession of the dead man's silverware and sweaters. The dead man left notes in his pocket: one night, he went to the opera.

The father of Juliette's children was an opera singer from Tehran. She first saw him when he was performing in *La bohème*. When they were married, she looked at his hand and said, "That wedding ring doesn't look right at all." He asked her what she meant, and she responded, "It doesn't belong there. It makes me uncomfortable looking at it." After their children were born, they divorced and he married her niece.

We went to the Catholic church down the street from Juliette's apartment. Sometimes my mother would drop me off there before going to Mass by herself. "Mooooooo," Juliette would croon. "Moooo," after my mother dropped me off at that small second-floor apartment in Santa Monica. I held the greasy white paper from the local Italian deli in my hands, eager to tear into the reward for saying goodbye to my mother. "Do you know what's in the meatballs of that yummy sandwich?" Juliette would ask, her tone a combination of pantomime and warning. "That's a baby cow, honey," she'd say. "Remember what a cow says?"

It wasn't until later that she began to dry-heave while passing the supermarket butcher counter. One Thanksgiving, she explained her aversion to the smell of blood: "I held my son while he bled to death."

I am reading Wittgenstein in a coffee shop with the intention of understanding Diebenkorn's use of color when I look up and see one of his paintings on the front of a record album behind the counter. The album, by the group Grizzly Bear, is called *Shields*, and the painting is *Blue Club*. In it, a small blue club nests inside of a larger white spade against a dark gray background. If you look at a spade and a club long enough, they begin to resemble the outline of some explosion. Different moments of billow: sagging low in the case of the spade, pulsing upward in the case of the club. "A vision dark and cloaked," Grizzly Bear sings. "And those figures through the leaves. And that light through the smoke."

"The ace of spades," according to Wikipedia, "has been employed, on numerous occasions, in the theater of war. In the Second World War, the soldiers of the 506th parachute infantry regiment of the American 101st Airborne Division were marked with the spades symbol painted on the sides of their helmets. In this capacity, it was used to represent good luck." Diebenkorn was in the military during the Second World War. He worked as a mapmaker. I try to find a point of connection between him and the 506th parachute infantry regiment. Both he and they were about to fly off to the Pacific theater when the war ended. Clubs and spades repeat throughout his paintings. From the *New York Times*: "'It is so much easier to talk about anecdote than about what's here,' Diebenkorn laments, tapping his heart, 'in the work.'"

●

A bookish young man lived in the apartment below Juliette. She and Ramin went to lunch with him sometimes. After he moved

out of that apartment on Seventh Street, Michael Silverblatt began to work at a radio studio located on the campus of Santa Monica College.

During the *Bookworm* interview, Silverblatt asks Joan Didion, "How do you avoid feeling sorry for yourself?"

DIDION: Because . . . it's been on my mind as something to avoid forever. And so it's just something I try to do.

SILVERBLATT: Were you taught it?

DIDION: Was I taught it?

SILVERBLATT: Yeah.

DIDION: I was taught about its value.

SILVERBLATT: 'Cause I remember one of the most startling things I've ever read anywhere is in one of your essays in which you were told to consider, instead of crying, putting a paper bag on your head, and you say: It was useful [*both laugh*]. It's kind of an amazing . . . I mean, at a time where feeling sorry and—as a nation, as a culture, as an individual, as a people—seems to be, you know, the national mood.

DIDION: If you can find yourself feeling better just by putting a bag on your head you would do it [*laughter*].

SILVERBLATT: Does it work? Does it still work?

DIDION: It does. It cuts off oxygen; it does something physiological, which works. It was explained to me, actually, how valuable this would be.

SILVERBLATT: That it was an alternative also to taking a cold shower.

DIDION: Right. It's much more effective than a cold shower and more available.

Around this point in the interview, Didion reads what the radio host deems "the final fugue" from *Blue Nights*.

I play this part for Juliette over the phone. "Let me just be in the ground. Let me just be in the ground and go to sleep." And, "The fear is for what is still to be lost. You may see nothing still to be lost. Yet there is no day in her life on which I do not see her."

"I have to go now," Juliette says.

"Oh, my," Juliette's old neighbor proclaims of *Blue Nights* on the air. "We are going to go as far to the edge in this book as it's possible to go."

◆

When I fell in love with a friend at CalArts' art camp for high schoolers, Juliette gave me instructions: take a shower. Sick with infatuation, I would take photographs of pay phones in stark black and white. She had sent me a copy of Michael Ondaatje's memoir, *Running in the Family*, and I became obsessed with his books. I made collages with quotations from *The Collected Works of Billy the Kid*.

I saw the author's name on the poster for a writing program in upstate New York. The taxi dropped me off at the dorms in Saratoga Springs. I came upon the college grounds at dusk. A child of the desert, I was surrounded by dense trees, and I was late for a reading by Ann Beattie. I glided across the campus, as you would, emboldened, across an ice-cold lake.

That weekend, my friend and I walked down the main street of the town. We looked behind us to see Michael Ondaatje a few paces away. No matter how fast we walked or where we turned, he remained behind, though oblivious to us. We felt as if we were following him backward. At the bookstore where we all ended up, I put on a pair of gigantic earphones and wept at the high notes of a trumpet played by some long-dead man.

"Thank you," I finally said, when I approached the author. He was a stranger whose voice had crackled from a cassette tape as I walked along a jetty from a beach in Kauai. Two administrators flanked him, protectively, and he waited for me to finish. I can't say, exactly, what else I came up with. Something about beauty. What I do remember is that his skin was dark against the glow of his white hair and beard. His body was stout. His eyes were blue.

When we begin to talk about her son's leukemia, Juliette brings up Ondaatje. The emotions that are beginning to overwhelm her bring his work to mind. She says, "Timbre. *Tim-brah?* Like when people sing, they have that sound."

❦

One of Ondaatje's characters is named Kip. He is listening to a radio when, suddenly, he screams. He has just heard the report about the atomic bomb being dropped on Hiroshima. His lover watches at a distance as he "sinks to his knees, as if unbuckled." When he closes his eyes, "he sees the streets of Asia full of fire. It rolls across cities like a burst map." When he closes his eyes, he sees people screaming, "the brilliant bomb carried over the sea in a plane, passing the moon in the east, towards the green archipelago. And released."

This scene is not included in the movie adaptation of *The English Patient*. The green archipelago.

When I was growing up, we had on the kitchen wall a Richard Diebenkorn poster of an etching called *Green*. On the lower left, there is a white object, which is like a white mountain, but it is also like a person sitting cross-legged who is being covered by a sheet. Above, the white shape echoes, as if its heft has sent out a ripple with sharp edges. There is a circle into which the colors and lines dip and curve.

Online, a US military target map from World War II shows Japanese airfields on New Ireland Island with a slumping shape, like a mountain on the bottom of the page. There is also a circle meant to indicate the cardinal directions, like a compass.

"I noticed the flashing light," one survivor says of the atomic bomb in Hiroshima. "It was not really a big flash. But still it drew my attention. In a few seconds, the heat wave arrived. After I noticed the flash, white clouds spread over the blue sky. It was amazing. It was as if blue morning glories had suddenly bloomed in the sky."

A science writer from the *New York Times* describes the explosion from the viewpoint of the aircraft that dropped the bomb: "As the first mushroom floated off into the blue, it changed its shape into a flower-like form, its giant petal curving downward, creamy white outside, rose-colored inside. It still retained that shape when we last gazed at it from a distance of about 200 miles."

Grizzly Bear sings, "And those figures through the leaves. And that light through the smoke."

Had he gone to Japan, Diebenkorn would have been part of a team of three—"a photographer, a writer, and a graphic artist."

In an interview for the Smithsonian, Diebenkorn explains, "So there was that which loomed in my future, and so I have to admit when the news came—and it came gradually—of the bomb . . . the word . . . ? 'We've dropped a huge bomb that's wiped out Japan,' or something like that. A crazy story. So it took about three days to really get it straight what happened. And I have to admit I looked at that whole, the whole bomb thing as, with immense relief."

SMITHSONIAN: Um hmm, sure.
DIEBENKORN: The war clearly was going to be over shortly, and . . .

SMITHSONIAN: And wouldn't depend on your group going out
with a sketch pad.

DIEBENKORN: Exactly. So the connotations of the atomic bomb
really didn't sink in for a little while for me.

SMITHSONIAN: Most people didn't understand.

DIEBENKORN: For most people, yeah.

Diebenkorn's *New York Times* obituary describes his physical form:
"He tended to hunch his large frame to make himself less impos-
ing, and when he spoke it was typically in a halting way, frequently
doubling back to what he had said to amend or correct a remark."

◆

I imagine her, years before her son got sick, noticing the way that
some paintings in the *Ocean Park* series, number eleven, for instance,
resemble waves. Red, pink, aqua, and pale-blue planes of paint ges-
turing toward the way it might feel for waves to collide against a
surfer's body. In *Ocean Park #6*, the colors are pastel, the palette kind
of comforting. But there is a sensation of a landscape that is being
drawn downward, twisting as toward a drain.

"I didn't want to keep Ramin from doing things," she says. "He
would get up early in the morning and put his wet suit on and take
his surfboard, and walk on down from Seventh Street and go surf-
ing. Now my mind was terrified because of sharks. But I never was
aware of the crap which was put out into the ocean."

◆

The English Patient is about a fictionalized version of the Hungarian
cartographer László Almásy. In the film adaptation of Ondaatje's
novel, he slips off while his travel companions prostrate during the
call to prayer. He has been searching for the oasis in the deserts
of Egypt, following a map that he drew while listening to a man

who told him to look for "a mountain the shape of a woman's back." When he enters into the cave, he finds paintings on the wall depicting swimmers, and he begins to laugh.

On the Wikipedia page for "Cave of Swimmers," someone has written, "Almásy devoted a chapter to the cave in his 1934 book, *The Unknown Sahara*. In it he postulates that the swimming scenes are real depictions of life at the time of painting . . . and that there had been a climate change from temperate to xeric desert since that time."

There are arguments about Ondaatje's rendering of the truth, whether it fairly interprets the motivations of Almásy, who sold his maps of Egypt to the Germans in World War II. Ondaatje's Almásy surrenders the maps because he is desperate. The woman he loves is in need of rescue, and he exchanges them for a plane with which to retrieve her.

●

The actress in *The English Patient* who plays the woman who takes care of the Hungarian cartographer after he has been burned is in another film. In it, her son has died. Willem Dafoe is a cowboy who guides the boy down a wet Parisian street.

The actress in *The English Patient* who plays the woman with whom the Hungarian cartographer falls in love is in another film. She plays a woman who kills her own son to spare him the pain caused by his illness. "The worst prison is the death of one's child. You never get out of it," she tells her sister.

In reality in the former, and fiction in the latter, both women are named Juliette.

●

For years, it was a kind of conspiracy theory that Ramin died because he surfed at the Santa Monica beach. One night, I find myself in the bathroom of a movie theater, sobbing in a stall. I am a little bit high, which makes me weepy, but still, unable to stop feeling sad at the image of Elliot Page, naked and strewn with flowers, curled into a grave.

Izzy, the character Page played, was part of an ecoterrorist group that tried to confront her father, who owned a company that dumped toxic waste into the community's drinking water. The ecoterrorists had watched a YouTube video of a mother attempting to prevent her sons from staying in the water too long at bath time, but to no avail. One died of cancer. The ecoterrorists try to force the owner of the company to swim in the water he pollutes just after the chemicals have been released. But before they can, he jumps by choice. He is apologizing to his daughter when a member of the security staff shoots her.

After getting home from the movies, I decide to google leukemia, surfing, and Santa Monica. An article comes up from United Press International, published October 17, 1980, around the time when Ramin would have been in the water almost daily. The article is titled "Five Lifeguards at Beach Near Storm Drain Get Cancer":

Santa Monica, Calif. (UPI)–Leukemia has killed one of five cancer-stricken lifeguards who worked on a stretch of heavily-used beach next to a storm drain suspected of spewing toxic material into Santa Monica Bay. Authorities confirmed Thursday that County Lifeguard Capt. Rex O'Dell, chief of the Santa Monica station and a lifeguard for 25 years, died Wednesday night of the disease. . . . On a summer's day the stretch of beach is packed with people "thigh-to-thigh," said one resident. Among the other four stricken lifeguards, one has been diagnosed as having Hodgkin's disease, one has thyroid cancer, one has intestinal cancer and another has leukemia. . . . A stretch of beach directly

in front of the drain was closed two days last year when surfers com-
plained of an oily substance on their skin. This summer the lifeguards
called health authorities because the water in the drain was purple.
Flood control engineer John Mitchell was quoted as saying last month,
"There is no doubt that from time to time there is toxic material in that
storm drain."

"Have you ever seen those videos where surfers ride inside of a wave?" I never ask Juliette. "Do you know that in the deepest part of the sea everything goes transparent?" Anne Carson writes, quoting a character in a film.

●

During an improv class, before she married and started a family, Juliette was called onto the stage. She remembers: "One of the teachers said, 'You're up, go on up.' And he said, 'You are completely and totally stranded and alone on a desert island.' Apparently I wandered around and I sat down, got very quiet; this was what was told to me. I just looked up and I looked around and I burst into tears. JUST SOBBING."

She was writing, around that time, for the *National Enquirer*. She would mostly leak spoilers about soap operas, but every now and then she took on bigger stories. When it came out that Michael Jackson was building Neverland Ranch, she invented all kinds of details about his plans for construction. "He sleeps underneath a pyramid," she remembers writing in the article. "When you sleep under a pyramid, you get wonderful energy." Her rendering was eerily close to the truth.

A tabloid newspaper recently published an article about a scientist who discovered two huge pyramids underneath the Bermuda Triangle. The material used for their construction was thought to be

both transparent and durable—perhaps crystal. When I read this, I am listening to an album by Philip Glass that has an illustration of a prism on the cover. Light refracts in all directions. Each ray a different color.

In *Einstein on the Beach*, an opera co-created by Philip Glass, one character tells, "I was in this prematurely air-conditioned supermarket and there were all these aisles and there were all these bathing caps that you could buy which had these kind of Fourth of July plumes on them. They were red and yellow and blue. I wasn't tempted to buy one, but I was reminded of the fact that I had been avoiding the beach."

\bullet

Not long after Ramin died, the Northridge earthquake sheared the balcony and stairs off of Juliette's building. A homeless man moved in after it was condemned. He lit candles in the bedroom, wore her cashmere sweater, and wrapped himself in Hermès scarves. She called over to him through her neighbor's window across the way: "It's a wonder you're not wearing my shoes!" He explained that her slippers were too small. "You have a ton of sterling," he called out, and she paid him to bring down her photo albums and family silver. "You don't drink much, do you?" he asked, noting the dust on her unopened bottles of liquor.

When he got older, Diebenkorn produced paintings that deviated from his most celebrated style. A print, for example, entitled *Flotsam* has rash strokes and a kind of messy violence, figures of people and *x*'s, liquids that have spilled, weapons. The cluttered space is not unlike a battle seen from overhead. "Is it gray? Or beige?" Juliette asks of *Flotsam*. I tell her it's black and white. She says, "If his colors were not the blues the greens the whites and that sort of the thing, I wonder if . . ."

"Threat provides the Sublime with its essential structure," Anne Carson writes, "an alternation of danger and salvation, which other aesthetic experiences (e.g., beauty) do not seem to share. Threat also furnishes the Sublime with its necessary content—dire things (volcanoes, oceans, ecstasies) and dire reactions (death, dread, transport) within which the sublime soul is *all but lost*."

One day, my dad stopped at the hospital on his way home. "Don't you leave me," he heard Juliette tell her son. In my father's memory, she stood at the edge of the bed, shouting. The boy kept receding. "Hold on," she'd say, pulling him back with her voice.

Before Richard Diebenkorn went abstract, his early work featured women who gazed out at the ocean.

Playlist for a Road Trip with Your Father in Honor of His Seventy-Fourth Birthday, Which Happens to Coincide with the Occasion of Prince's Death and the Release of *Lemonade*

1. "When Doves Cry"—Prince

Dig, if you will, the picture. A choreographer who is one of your father's oldest friends is driving like Paris Hilton in Rome through the parking lot of a fancy hotel. You are repressing a smile in the back seat because Black people who drive recklessly make you feel like THE REVOLUTION HAS BEGUN. The choreographer says into his phone, "Did you pick up Sade?" and all sound stops. Walking toward the hotel in a torn Ann Taylor Loft sweater that you have worn for every professional or semiformal encounter you've had over the course of the last five years along with what your girlfriend calls "your Whole Foods pants," you turn to your father and mouth the word: *Sade?* He stage-whispers back, "I wouldn't be surprised."

For the next ten minutes you are not sure of whether or not you will be dining with a woman who, at fifty-one, told Beyoncé ALL ABOUT "Formation" while throwing a lasso around in circles above her silver-suited body on the white-stallion version of Mars.

This is what it's like to travel with your father.

2. "When Doves Cry"—Prince

Your father is the kind of person who announces, loudly, "My daughter is gay," when he hears people talking shit about gay stuff, even if this is not the language you would use to describe your sexual identity. Your father is also the only person in the world who knows how to frustrate you enough that you could dislodge a telephone pole and throw it across the street. This may be why the last time you went on a road trip he called you a witch, at a point when the term was not widely synonymous with words like *intuitive* and *grounded*.

There will be a moment in Brattleboro when your father is standing in the middle of the street whispering angrily about your temper on the phone to your mom while you scream "GET OUT OF THE STREET," but we have gotten ahead of ourselves.

3. "When Doves Cry"—Prince

How does one find oneself on a road trip with one's father smack-dab in the middle of their thirty-fourth year of life and on the very first day of his seventy-fourth? Especially given their tricky track record with father-daughter road trips? Well, what would you do if somebody invited you to be part of a literary festival in a town with lots of gorges? Catch up on season five of *Girls* in the light-drenched room of your fancy B&B while sipping coffee or wine in your pj's?

No. This is no time for greeting cards. When you are invited to a literary festival there is no one in the world who can help you appreciate the honor like the father whose literary ambitions you have sauntered off with like an overeager relay racer. You invite your father to fly into Ithaca so that he can *join you* for each and every event associated with the festival. "My dad can come to another comped dinner? No—really, you don't have to—are you sure? OK."

And good that he did. Who else would have asked the South African short-story writer about the Rhineland Bastards over Thai food? And over coffee the next day? And after the Q&A the day after that?

It is much more fun to watch *Girls* with the volume almost all the way down while your father sleeps in the actual bed and you sleep on the can-you-believe-it-they-just-so-happened-to-have-a-daybed-don't-let-him-sleep-in-a-motel with your ear facing the television. All you have to do is fast-forward through the sex scenes, lest he wake up and ask why you are so fascinated by these constantly naked white people with tattoos.

4. "When Doves Cry"—Prince

You find out that Prince has died from your girlfriend on the phone after something that is actually true happened. Which is that Pam Grier liked her tweets. Pam Grier liked your girlfriend's tweets about Prince.

There is a poet at the conference who was born in Somalia and grew up in Ohio and who is so poised, it's like THE SUN EXPLODED AND A WOMAN WALKED OUT. She spent the evening before Prince died whispering some kind of Lorraine Hansberry–meets–Nina Simone, pure-gold-wisdom art-love into your ear and your heart was healed and your dad was there and it was his birthday and everybody sang even though they'd just met him. All of this to say that the poet sings "When Doves Cry" at the beginning of her reading. All of Ithaca falls silent.

While the poet sings Prince your father places his audio recorder underneath the video camera set up by the conference organizers, just barely managing to not knock it down. There are moments during the festival when you and your father and the poet are the only

Black people in the room. Even when he is not there, when you are the only Black person in the room, he is also there.

5. *"Guns, Germs, and Steel"*—Jared Diamond

Festivals have to end. A lot of Thai food happens. A lot of grace and a lot of Thai food and your father seems to have enjoyed it. It is necessary to drive many miles away in order to arrange for a car rental, and a very short man who waxes poetic about how much he loves his grandson is involved. Also, a microwave and some leftovers that your father seems to think you have made into too much of a thing, *just throw that away.* The taxi driver who is playing with everybody's heartstrings requires a lot of eye contact in the rearview mirror, so you are relieved when your father jumps into the conversation with questions about things like Bismarck. This is a purple taxi. PURPLE.

There is an adage about men not wanting to ask for directions. But once you and your father have driven back from the rental car place to Ithaca and exhausted yourselves at the bookstore's big annual sale, you let him talk about Lena Horne's daughter for a good half hour while you pretend to know how to get to Rochester. You discover that there are such things as white "mystery" Airheads while buying a map at a gas station fifteen miles out of the way. Your father, unsure of where you have gone, makes conversation with people who look, when you return, utterly bewildered by the both of you.

Because you drove without knowing where you were going for so long, he gives you the silent treatment for a while before returning to the monologue he started about Gail Lumet Buckley, Horne's daughter. There are things to know, apparently, about Gail's husband, about some books that some people associated with both of them have written about Vietnam, and about a book that was never

written about Vietnam. You love that your father is interested in this information without quite knowing what to do with it.

The audiobook that your father has chosen for the journey to Vermont involves a question that, though explored in a manner that does not make you feel fully awake, elicits an exchange of raised eyebrows between the two of you: "Why aren't Africans, Aborigines, and Eurasians the ones who decimated, subjugated, and exterminated other nations?"

Why indeed.

At different phases of the drive you are working together, like when you turn by the vineyard. At other phases of the drive you are not working together, like when he realizes you are going to be late for dinner with Garth, and you, your father, the phone, and the freeway enter into some kind of military-industrial complex. "BE NICER," you say when he answers the phone with subpar enthusiasm, and the violence of your tone makes the car shake.

6. "When Doves Cry"—Prince

The Sade who joins you at the hotel restaurant is not the Sade who gave you all the love she got she gave you more than she could give she gave you love. But she is a Sade who, you realize after a bit of googling, can flex muscles in her leg that most people will never know about and who may be one of the best dancers in the world even though she went to school to be a doctor. She will talk to you about making paintings in Romania while you eat food that tastes like dreams of food.

A waiter whose persona seems to have been inspired by the Steve Martin hamburger scene in the remake of *The Pink Panther* keeps pouring wine. You win an argument about the name of a jazz biopic

even though your sparring partner has spent some SERIOUS time with Wynton Marsalis. By the end of the day you will have heard stories about artists whose names you have searched for in the stacks of many libraries, like one that begins with "Romie called me one morning" and ends with a dick joke the butt of which is, somehow, the *New York Times*. You fall asleep in a blue room on a mattress that wants your lower back to just go ahead and peace out. But you feel like the number-one luckiest girl in the world.

Downstairs in the dark, Aunt Jemima smiles from the confines of a painting, giving everybody the middle finger.

7. "Rumble in the Jungle" (feat. Busta Rhymes, ATCQ)—The Fugees

When your father is one of very few Black photojournalists for *Newsweek* magazine in the sixties, seventies, and eighties, you get to have childhood memories like this one, in which a house, dimmed, smells like food. A legend moves slowly in and out of rooms. Someone is getting something for somebody else. This is the moment when you will learn that Muslims don't eat pork, which is something you learn because Muhammed Ali explains it to you. He pulls you onto his lap and proceeds, with painstaking precision, to write his name on twenty squares of paper for every person in your elementary-school class.

"Who is the greatest?" he asks. The little girl version of you points to the man whom every person on the planet has agreed is the greatest. "No," he says, pointing to your father.

I believe it was Hillary Clinton who said that it takes a boxer who went to a village in Africa to fight George Foreman to raise a child without letting her internalize everything America has told her about Blackness and her father.

OK, Kinshasa is not a village.

8. "When Doves Cry"—Prince

At one of many identical rest stops, the two of you stand gaping at a flag, wondering what on earth it might be at half-mast for. The tragedies have become too profuse to count. "Is it Prince?" you wonder aloud, and you both take a moment to consider whether or not you believe that that kind of a reality is the same reality that you are currently living in.

A very thin highway brings out a brief speech about a Black woman your father once met in the South who had some advice about AAA TripTiks that he does not feel you are receiving with sufficient gratitude. But maybe this woman sounds like someone your father has made up because the description of her lacks the kind of precision he brings to other stories, stories about, for example, Gail Lumet. Stories that aren't a veiled attempt to criticize your route-planning sensibilities.

That night, you are welcomed by old friends who don't care that they could hear you fighting loudly on the phone. You meet a new friend who spent the day exploring an abandoned mental institution with her camera, *so who even cares if you got into a fight with your dad when's the last time the two of you went on a photography adventure.* "Mom says we're too much alike," your dad says by way of a truce. You drink wine and eat late. Your father tells that one story about performing in *Aida* for a dollar. The son of this household thinks your father is one of the most interesting humans alive. You practically knock that guy over, reclaiming your dad as your own.

9. "When Doves Cry"—Prince

In Brattleboro, you sit in the window of a café together, your father in his fedora, you in your Whole Foods pants, and a man walks by, walks back, walks by, then walks back and enters into the café. "I

thought you were a display!" he says, so full of good intentions that the only option is to rejoice in this proclamation along with him.

A little later, your father says, "The Black guy we saw earlier didn't speak," which begins your favorite conversation, the one about being exaggeratingly cordial with the sparse men and women of color in a small white town. And you say, "The one at the co-op?" And he says, "There was another one?" And you imitate the way this man nearly fell out of his seat while he watched the two of you. "So there were two," your father determines.

There is a bookstore with such a good display of African American contemporary poetry that you don't feel self-conscious that the shop-keeper is watching to see if you are stealing. This means a lot, you realize, about poetry.

It is time to go when, at seven o'clock the next morning, your father has unsuccessfully recapitulated Jared Diamond's explanation for the white supremacist delusion of intellectual superiority in a con-versation you are having with a tired widow who was hoping you'd end this visit on a slightly more upbeat note.

10. "Ol' Man River"—Paul Robeson

Your father will be dropping you off for a teaching gig in a small New Hampshire town. Trump signs dot the horizon with a fre-quency that has both of you whining softly. When you say something about "the sign," your father says, "Sign of what—the clan?" He's just getting started. When you say, "That's where I go when I need to get away," and point to the McDonald's, he says, "So that's your Black Donald's?" He's not normally one for puns.

At the restaurant where you have lunch, he chooses a booth far away from the bar full of white men who are watching sports over a

midafternoon beer. When you grimace at the insulin shot he is about to pierce through his abdomen, he pretends to wave to get the attention of the men at the bar while he pantomimes tying up his arm like he's about to shoot heroin and flicks a vein. Who is this guy?

Before seeing him off, you show him to the bathroom of the inn where you will be staying for the night, the location where you will be parting ways, which was just inundated with many inches of sudden snow. Your father is talking about how Bobby McFerrin's father would sing arias while he mowed the lawn. A man is trying to get into the bathroom behind your father while he tells the story, for the benefit of a mostly empty lobby, of Paul Robeson in Silver Lake—how his neighbors met his daily vocal exercises with thunderous applause.

It is only you and the man who has to pee, and neither of you is clapping, but you feel awe at the fact of your father filling up every last inch of the room.

11. "Pray You Catch Me," "Hold Up," "Don't Hurt Yourself," "Sorry," "6 Inch," "Daddy Lessons," "Love Drought," "Sandcastles," "Forward," "Freedom," "All Night," "Formation"—Beyoncé

Your father blows you a kiss and you watch him drive away in the snow. You get to the hotel room and finally realize what your girlfriend meant in her texts when she kept saying the word *lemonade*. You put the laptop on the toilet and watch the film from the hotel bathtub, sobbing.

Even though the entirety of New Hampshire is glowing white, a white guy with white hair at the coffee shop the next morning will ask you apropos of nothing how you think Jay-Z reacted to *Lemonade*, and you will say, "Well, he's IN IT," and life in the big bad world rolls on.

How to Teach a Nightmare

The caterpillar I just stepped on oozes like Nickelodeon slime, half smashed. We crouch over it. I poke the now curling body with a stick, trying to move it off the trail so it doesn't continue getting pulverized. I know better than to think that the cold air I feel for killing a bug is what's wrong with me. We start walking again. I tell the student I am hiking behind that I'm scared.

This is my first time teaching for the New England Literature Program, affectionately referred to by participants as NELP, which you might think of as a study-abroad program for English majors. Instead of going abroad, though, we go back in time—into the woods of New Hampshire, without computers or cell phones. We have spent the last few weeks of spring reading authors like Thoreau, Dickinson, Douglass, and Emerson on the grounds of what normally functions as a boys' summer camp. Students swim or canoe in the ice-cold waters of Lake Winnipesaukee. When we aren't in class on the dock or at the fire pit or in the meadow, we cook and clean in teams. The only music we hear comes out of instruments. One student, Kara, later shares with me a description of the nightly serenade, recorded in her journal: "Danny is playing the piano and Nemo is next to him singing in a sweetly toneless voice like the world's most mild lounge singer."

At this point in the program instructors are to come up with a literary-themed adventure into some part of New England. My friend Mary has asked me to lead a trip with her that other NELPers have taken in years before. We will stay at the Bread and Puppet Theater company in Glover, Vermont, for a couple of days. The founders, Peter and Elka Schumann, are close with the poet Galway Kinnell, and it is possible that we will be able to visit him, too.

We have stopped along the way to take a hike. The day is particularly radiant. The student hiking in front of me is named Leela. She has eyes not quite as green as the crushed caterpillar, but in the glow of these trees, what I've started to call the "Brazilian rain forests of Vermont," she bears a certain authority. When we evaluate her work, I will describe her as a "forest sprite," and the faculty will nod cautiously as if to say, "No more hippie shit."

The reason I am scared is that Galway Kinnell has Alzheimer's disease. One of the biggest fears of my life is that my mother will become unrecognizable to me, and I to her. That she will wander off in plain sight. Each time she forgets a word or pauses, I unfurl into a kind of monster. There is nothing in the world that makes me more upset. I am bracing myself against the emotions this visit might spark, as if trying to keep myself upright. "It came to me that the presence was still there," John Gardner once wrote, "somewhere deeper, much deeper, in the night. I had a feeling that if I let myself I could fall toward it, that it was pulling me, pulling the whole world in like a whirlpool."

We have been climbing mountains every week, which intimidates me. Rather than hiding my unease, though, my pedagogy is not unlike a trust fall. I name my fears one by one, complain about the incline, request water breaks to catch my breath. To test our emergency response skills, we impersonate disaster at the cloud line, where I pretend to be unconscious. Cheek flat against the rock, I wink an

eye open as they debate who will stay with me and who will return to the base of the mountain. It makes me happy to be the subject of this imaginary caregiving.

In an attempt to comfort me, Leela tells me about the time she went to India and handed her great-aunt a pair of earphones, then watched the old woman smile at the sound of a silent orchestra.

We hike in the direction of water. I bleed into a tiny cotton plug, which in the woods I've come to think of as a tracking device for bears. I walk off to conduct my constitution in private, and notice that despite my effort to hide behind trees, a student could have seen me. Kate has the bemused eyes and wry stance of an actress from another era. Katharine Hepburn in Gore-Tex shorts. I was in her peripheral vision while I peed; while I folded aluminum foil around the tampon, put it in a Ziploc bag, and shoved it into my backpack; while I used a Nalgene to wash the blood from my hands. There is no room to feel mortified. A photographer friend has recently told me about women who managed to hold entire books in their heads for thirty years by refusing to think about anything extraneous.

In Galway Kinnell's poem "The Bear," which my co-teacher and I have included in a packet of supplementary materials for this trip, the narrator follows "splashes / of blood wandering over the world." He eats a blood-soaked turd. The moment sounds disgusting out of context, but in the poem it is one of adaptability. A sign that this man will do what it takes to survive.

As we approach the place where we'll eat our lunch, Mary points up and says, "Look! It's the night sky! An indigo cliff!" The rock wall is slick with a thin waterfall, black and long as outer space. The path disappears and some people go on ahead to find it. A few of us aren't feeling athletic today and take a five-minute break "to meditate" until the trail gets found.

During the silence after lunch, we read our packets. In an article from the *New York Times*, Holland Cotter describes his visit to Bread and Puppet as the occasion of "the single most beautiful sight I've ever seen in a theater." He recalls a performance during its then annual two-day festival, Our Domestic Resurrection Circus, when a fire was lit on the field used as a stage:

As the fire burned, a half-dozen great white gulls or cranes—muslin kites carried on sticks by runners—soared up from the horizon and started flying in our direction. They came right to the flames and soared over them as if looking for signs of life. Then they circled back across the field, melting into darkness. It was fantastic. Only when they were out of sight did I see that night had fallen and stars were out. It felt like an impossible trick of stagecraft, a miracle. I had been simultaneously transported and pulled back to earth.

He refers to another performance, entitled *The Fight against the End of the World*, which seems as good a way as any to articulate the theater company's intentions. Its members function as a collective. For years, even while traveling, they have made bread in hastily constructed outdoor ovens as a gift to their audience.

In the car that day, we are quiet as Leela sings in the back seat. Kara writes in her journal, "Her hair heavy with lake water and strung out over glistening shoulders. Like heartstrings or gold. Singing so under her breath (like borrowed breath), big lily pad eyes and we are lost but the trees burst to constellations as the tires turn, bent by the crowbar of her song."

When we arrive at Glover, we know to turn onto our host's property because of a painted school bus off to the side of the road. The museum and indoor performance space called the Cathedral exist within renovated barns. Maura, who welcomes us, seems to appear out of nowhere. "She received us in a rose-print slip and Croc clogs,"

Rachel remembers. She is so beautiful, the students will dream of her that night. A modern-day Glinda the Good Witch. Prophecy of some future they didn't know they wanted. She encourages us to wander around.

We immediately come up with a plan to practice cartwheels in the tick-infested tallgrass across the street, where Bread and Puppet hosted Our Domestic Resurrection Circus for decades. This is the closest any of us will ever come to living in the seventies. We peer into trailers where actors or volunteers must live, which dot the path that leads to the field, and we gasp at the perfectly made beds inside. I am gaping in the window of a tiny Airstream when I realize there is someone in there. It's not merely a stage set. The chicken strung up alongside the little home is newly dead. We start to feel the kind of camaraderie you experience when the lights go out on a subway.

Something pulls us toward the line of trees on the horizon. Sunset leaks through. One by one, we pass through the threshold of forest and fall silent.

It takes a while to realize where I am. I can sense from the students who have woven their way through the tiny houses built at the base of tall, thin trees that something somber is afoot, and my sense of anticipation grows. This is it. The shadow I've been waiting for.

There are wooden structures scattered among the trees. Photographs, trinkets, hanging things. One photograph in particular catches my attention. There is a birth date and a death date, an image of a woman in outdated clothing holding a child. Then, another tiny house, this time with a letter in translation: a Polish woman addressing her children after having been taken to a concentration camp. The shadow of mortality, this pool of feeling, is less offensive than I'd anticipated. It feels weirdly warm. There is a memorial for an actor. One for Grace Paley. There are poems about chickens. "Gravestones," Kara writes,

"are about permanence that has nothing to do with the way a life actually is. But these, even as they decay, as the memories of these people fade, they seem so peaceful out here in the open."

That night Rachel will tell the same joke over and over again. Possibly at my request. We will laugh convulsively as rank humor slides, reckless, out from under her innocence like a car skidding sideways on a wet road.

The first indication that we are in another country is that our logic begins to change. We have chosen the least comfortable of three sleeping options—bunk beds? camping?—to nestle our sleeping bags in a circle on a dirty floor. Perhaps it is the opulence of the name: the Ballroom. Or is it that we are living inside of a poem? We are no longer operating under the same grammatical rules. Kate writes in her journal, "It's called the Ballroom, but there are old car seats—seat buckles still intact—scattered across the room."

Mary and I want to hold class that night, even though it's late. So we drag the sleepy bodies to the Cathedral. Kate writes, "There are hundreds—maybe more—of relatively petite, potentially medium-sized, puppets mod-lodged onto the walls in this big wooden barn. The benches are stadium style." The automatic lights turn off when movement stops. We read from Kinnell's *The Book of Nightmares*, small pulses of lyric, then pause. "The last trace in us of wings," someone reads. And the darkness falls. And we wave our arms. The moment is recorded like a passport stamp in our journals.

I once took a meditation class with a punk-rock cabdriver turned Zen teacher, and we learned a form of meditation where you imagine yourself dying and dead, and then do the same for every person you love. Every step we take toward Galway Kinnell feels like a breath taken in the space of this corpse meditation. A morbid learning that leans toward brightness.

A moth in the darkness scares the shit out of somebody. There seems to be a collective gasp when, in "Under the Maud Moon," the narrator tells of his baby daughter: "she who is born, / she who sings and cries, / she who begins the passage, her hair / sprouting out, / her gums budding for her first spring on earth, / the mist still clinging about / her face, puts / her hand into her father's mouth, to take hold of / his song." It is as if it is our first spring on earth, too. The poet is telling his daughter how to live by telling her that he is going to die. "This is the kind of poetry," Leela writes, "that sticks to my ribs."

I rise early out of fear that we've slept too late. The sun feels low in the sky for 6 a.m. I meditate on a workshop table labeled "Tongues." Melissa had a dream of a parrot that came to life and gave her a hug, and I point to the photograph on the wall of a woman holding a falcon. We are about to work for the morning weeding the garden, singing a song that Rachel will teach us. First, we will meet the new chicks. First, Scott will prompt us to wonder whether or not Andy Goldsworthy is performing a public or private act with his art. Whether or not nature can act as a stage. In a photography book, black-and-white images from the field across the street show manifestations of power, longing, war, and grief parading like giants across the sky.

On a tour of the Bread and Puppet barn-cum-museum, which Holland Cotter describes as "a coup de théâtre . . . intricate moral and narrative cosmology," I feel constantly seized with the impulse to turn around, because I can see a puppet out of the corner of my eye. I am drawn to hold the hand or face of that puppet in a way I don't feel toward actual humans. Our tour guide's hands are enormous. She points up and we see a giant face gazing down from the ceiling.

A piece of paper on the wall reads: "The story of one who set out to study fear." At a demonstration where they once performed, the

actors carried the body of a wounded protester to the feet of an armed guard. I don't imagine that repressive regimes train their soldiers to know how to respond when a book from their childhood comes alive. Pulling a gun on a protester may not be that different from screaming at the top of your lungs in the beat of your mother's pause, terrified of her forgetfulness—so strong is the impulse to refuse that we are all only ever moving in one direction.

When we arrive at Galway Kinnell's house, we discover that his dogs have just run away. "Hello," he says to Rachel, shaking her hand. "My name is Galway." The poet looks around, flickering between the role of host and the role of heartbroken, trying to explain his predicament as his son, Fergus, completes the narrative. Kinnell wears blue sweatpants, tennis shoes, a red shirt, and a greenish sport coat. He speaks in fragments, but conveys his heart by saying the name of one of the dogs, Willie, and referring rather frankly to what he fears will be the dog's "imminent death." Rachel's favorite section of his poem "Dear Stranger Extant in Memory by the Blue Juniata" is the part where he writes of "Tenderness toward Existence." She hears him say of his labradoodle, "Oh, dearest one."

"The time here has been full of observing how one interacts as a guest to strangers," Leela writes in her journal. She particularly likes how Kinnell's poetry "really and with genuineness draws from his true loves and combines, in this exquisite tango, the wild and what some might refer to as the 'domestic.'" Kara has a similar feel for the work: "There's something within it that feels ancient and dark and strong—an extinct animal in your living room, wildness in the domestic space."

There is a photograph of Muhammad Ali in the kitchen. Rachel and I have come inside the house to use the bathroom, which has a European-looking toilet. But neither of us wants to stop looking around. Ladysmith Black Mambazo is playing on the stereo, which

feels like a cheap trick—both of us grew up with mothers obsessed by *Graceland*. So it is that we are swooning in front of the refrigerator magnets, cataloguing every detail, unsurprised by each new moment of synchronicity. The Marge Piercy quote on the poster that we encountered in an assignment a couple of weeks ago. The fact that Kinnell will choose to read "Under the Maud Moon." At which point we'll gasp like we did last night. And the dogs will come back home. "O, holy," Rachel writes in her journal. "The whole thing seems desperately miraculous."

At Kinnell's house, we sit in a circle outside. When I pass him the ziplock bag of cookies he takes one and says, "Can I have another?" Even at this advanced stage of Alzheimer's, he sculpts the space, coaxes us to read, scolds us for soft-spokenness, congratulates us for good recitation. "Wonderful," Rachel hears him say after each poem is recited. Upon our host's request, Kara, with her head half-shaven and a gaze like windows, begins to speak a Keats poem she never knew she'd memorized. It will move him, and it will make her feel "like I was a vessel, almost, with the words going through me."

"Now," Kinnell says, "does anyone want to read a poem?" It doesn't matter that we are already reading one. It doesn't matter that he is already reading his own. "That's nice," he'll say, pronouncing his poetry as if for the first time. Kate notices that when he reads, it gets silent, and his voice changes—"deeper, raspier, and round." His approximations of language cast the afternoon into something dreamlike. Fergus points to a tree: "That's where I fell when I was a boy." Because this refers to one of his father's poems, we titter, starstruck.

We sit on the stone table. We swim in the pond, or "baptize ourselves," as Leela puts it, because "you can only swim in Galway's pond once." Rachel describes the landscape we are walking across as a "hill of clover, dandelion, and grass going to seed." Leela makes bouquets with dandelions for Mary and Kara and the flower

stains her fingertips like paint. It has only been one day, but we are wilder, yellower than before. Our clothes are wet. Some of us are barefoot. And if you told us in this moment that we might one day be orphans, "emptied / of all wind-singing, of light," we might not turn our heads.

"Would you like to go down there?" Galway Kinnell asks, without announcing where "there" is. "We must proceed with reason." I try to imitate an adult in my reply: "I should hope so." But I am hopelessly a daughter. Sitting at his knee. Reaching into his mouth. I take both his hands in mine as if flinging myself into the arms of a puppet. I wonder from the sudden glint of a question in his gaze if I've overstepped my bounds. His eyes are globes of green in his face.

When I find out that he has passed away, I read *The Book of Nightmares* in a library, tears coating my face like sweat, snot smeared across my cheeks and hanging from my nose, as I slide quickly back into that long-past wildness. I will know without needing to ask that I'm not the only one of us to feel the memory, that intimacy, encroach upon the day like weather.

Later, we will drive through the fog at night and eat Magnum bars from a gas station manned by a clerk who'll say, "I'm so high right now." The stories we'll tell on the car ride toward our ballroom will get lost like brake lights in the thick moisture of the night, and then resurface. Of the trip, Kara will write, "This is a good moment of time in a strange space."

Later, in the small home of the Schumanns', we will eat apple fritters with coffee. "The apple fritters are the most important nourishment I've received these past few weeks," Kate will write. Peter will tell of his next project: "We had an ice storm. It bent the birches." Elka will sit beside him, rubbing the handle of a Christmas mug with her thumb.

How do you teach a generation how to visualize their future when words like *extinction* appear on the front page of the *New York Times?* "We must use these gateways," Peter tells us. "We will build a king and queen to go through them." Because there are gifts in the storm.

This essay was written with the help of Leela Denver, Rachel Pernick, Kathleen Harrington, and Kara Mullison.

D Is for the Dance of the Hours

My father performed in his first and only opera while he was a college student, working at the Detroit Public Library. He had no aspirations toward performance, just a crush on Leontyne Price. With politicians in the audience, he was warned not to disrupt the dignity of the opera as he played the role of the pharaoh's guard in *Aida*. But my father found it difficult to keep a straight face while the high priest and the pharaoh gossiped about a sexual exploit with a female member of the cast, crass as they breathed between songs. My father was paid a dollar, and missed out on dinner with the company afterward because that dollar was all he had and he needed it to get home.

Both my parents are from Detroit. I grew up in California hearing stories about a city more laced with wonder than desolation. We know it as the birthplace of gallerists and world-famous choreographers and raucous family dinners. Though they've spent most of their lives in LA, my parents began to frequent Detroit a few years ago, preferring to be closer to family. They moved there permanently this year.

On a prolonged summer visit to Detroit three years ago, I would play classical music while running errands. Each time, the world

seemed to click, suddenly whole in a way I couldn't have realized, seconds before, that it wasn't. Colors pair best with their opposites: turquoise and vermilion, bloodred and new-growth green. And in this way, the east side of Detroit is complemented by music that comes from worlds away: Burned wood and the entrance of a conductor. Overgrown grass and the sweep of a violin bow. A baby carriage tipped over in an abandoned lot and the hush that comes between a song's end and the applause.

One year, my father and I drove across country from Tucson to Detroit. He put on the "Flower Duet" from *Lakmé*. Two sopranos sang bel canto as the night swelled black outside. Ground beneath us tilting downward, we fell through all that nothing toward a factory's blinking lights, car cascading into sound.

In his article "Detroitism," John Patrick Leary explains that most writing about Detroit tends to fall into one of three subgenres: metonymy, by which the city stands in for the auto industry; lament; or optimistic delusion. Given that the running metaphor in this essay is opera, I'll self-select: this is a lament.

◆

When I visited the Detroit Police Department's Ninth Precinct that summer, portraits of fallen officers greeted me. Elmer Cox died on May 5, 1925. His face is doll-like, or deer-like, his eyes sheen and shadowed. Alonzo Marshall Jr. died on September 1, 1971. In his portrait, he seems confused. I wrote down their names: Sypitowski, Bandy, Steward, Tralk. Somebody died in the year of my birth. I recognized the name of a man, Huff, who died after my cousin became this precinct's lieutenant.

My cousin tells us stories about her job, like anyone else would. But a normal day for her involves a woman who lived with her dead hus-

band for two years. He sat in their living room, silent on an armchair in front of the TV, as she went about her business. By the time they found him, he was mummified.

At one house, presumably among Detroit's many mansions, my cousin says, there was a branch the size of a large tree in the middle of the ballroom, home to a giant boa constrictor. Cops routinely answer calls about tigers and monkeys, pigs and birds. When I ask what the snake was for, she says, "That's where they bring people who fuck up." Certain animals are a form of exotic torture favored by drug dealers, for when people don't pay their debts.

"On the west side, they'll rob you and kill you," she says. "On the east side, they'll rob you, kill you, and rape your corpse." It took years of invitations before I finally decided to ride with my cousin for a day while she was on duty, in 2012.

Though I began to write this essay then, I have hesitated to share it because there is an implicit understanding among people who love Detroit that you shouldn't talk shit. And I love Detroit more than I do most places in the world. A sense of possibility and kindness emanates from all that chaos in a way that is hard to explain. But censoring trouble doesn't make it go away. James Baldwin and the Buddhists have long argued that healing results only from staring struggle straight in the face. The late philosopher and activist Grace Lee Boggs spoke of Detroit as a kind of ground zero upon which to visualize a new world order. So, here goes.

●

Before she died, my grandmother spent most of her life in my cousin's precinct. One of the last times I saw her alive, she told me a story she'd seen on the news. An elderly woman had been strung up and bled, like a side of beef, by two men who worked for her after they

stole money from her purse. Perhaps because of stories like this, my father was always a little wary of the cast of characters that passed through the house she shared with her younger sister, Cora Mae. So he kept close tabs on each of them. June visited out of grief. He couldn't make it to his own mother's funeral while he was in prison, so upon his release he devoted himself to my grandmother in penance. Gracie was attentive, but her eyes were glazed, and my great-aunt never failed to point out that she always arrived at mealtimes. Fred was known as an old-school hustler, but he would keep my grandmother and great-aunt company in exchange for a morning cup of coffee.

After my grandmother died, Fred continued to visit with Cora, and my father periodically called to speak with him. Because my dad and I have almost identical phone numbers, I often got calls for him. One day, I received a message that began, "Lester-ah, this is Fred," the voice gruff like a heavy man's gait. I didn't think much of it then. That was the only time I heard Fred speak.

A few days later, Fred's body was found in the tall grasses across the street from my grandmother's house. He was bent and tipped over to the side, so it looked as though he'd died and entered rigor mortis while seated—dumped into the empty lot hours later. At the crime scene, my dad listened as Fred's daughter relayed what the police had told her to the gathering crowd of neighbors, wailing the details of his demise like a distraught paperboy or a backup singer. "It was really quite moving," he repeated throughout the day.

We eventually found out that Fred had been drinking heavily when he had a heart attack. Suddenly faced with a body, his friends panicked and left him in the lot. But because he died under mysterious circumstances the day before I rode with my cousin, some part of me felt like I was embarking to solve his murder. As I hardly knew him, what his inexplicably dead body symbolized more broadly was the

rupture of my grandmother's neighborhood. That day, I set out to collect clues that might reveal the phenomenology of the city's collapse. A kind of autopsy.

From the shelf, I've taken down my father's book: the 1972 edition of *The Concise Oxford Dictionary of Opera*. *A* is for Azucena, a gypsy in Verdi's *Il trovatore* who watched her mother get burned alive. *A* is for Giuseppe Anselmi, the Italian tenor who left his heart to the theatrical museum in Madrid, where it is being preserved.

◆

On the day of the ride-along, I am instructed to wear "business casual," which is a clothing style I've always struggled with. So I borrow my father's bright white button-down shirt and my mother's trousers. My father had been unaware of how I planned to spend my day, and his concern hangs in space like an air-raid siren.

As I walk through the back door of the precinct building with my cousin, an officer coming off duty points at his cheek for her to kiss. She gives a sideways smooch, then grabs at his wrinkled shirt and asks, "Was this in your car?" There is an eagerness for affection in his response, a childlike kind of purr. In a country full of awkward hugs and handshakes, my cousin greets people like a European. This might help explain how unusually disarming she is.

I follow her into a large white room. The floor is worn linoleum and a long, slanting pole connects it to the ceiling, which makes the room feel askew, as though just hit by an earthquake or flood. There are scattered desks at which nobody is sitting. File boxes are stacked precariously along the sides of the room. A fish tank sits next to a coffeepot, fake lilies, a box of green tea. It's like an empty, disheveled stage set. When I gape at the bright-red concentric vents on the ceiling, I am told about the mice that fall out of them in a tone of disbelief

meant to emphasize the extent of the disorder here. There is a photograph of a barn on the wall.

On the water fountain in the hall, someone has taped a piece of computer paper with a typed warning: "Don't drink the water." I sit down in a chair that will collapse if I lean too far over to the right. At the public entrance, there is a sign that reads, "Welcome to the Eastern District. To better serve you, the district will be in virtual mode from 4 p.m. to 8 a.m."

"The craziest thing to come in that door?" my cousin says. "A man bouncing a basketball, shooting."

◆

A year after my ride-along, the city will declare bankruptcy, and my cousin will drive up in a brand-new squad car. She will show us pictures of the department's renovated kitchen. The city will have hired two hundred new police officers and one hundred new firefighters. Crime rates, though still horrible, will have gone down about 20 percent. Police and EMS response rates will have improved dramatically. Fingers will be crossed. But on that day in 2012, the precinct is in a state of chaos. Seventy-five million dollars have been cut from the police department budget. Officers are warned to be on their best behavior because something in the area of one hundred layoffs is rumored to be hitting soon. Precincts have been merged. By the time officers make it across town for distant calls, the crimes they've come for have become old news. The mayor has announced that 164 firefighters will be laid off, despite the fact that arsonists keep the city lit like a bank of devotional candles. Fire stations receive news of fire via fax machine and use soda cans as alarms.

Shadow figures from Kwame Kilpatrick's days as gangster-mayor still haunt the halls of government. Corruption is eating away at the

infrastructure of the city like a termite infestation. Weeks after the ride-along, a friend will send me the link to an announcement made by the Detroit Police Union warning potential Detroit visitors to "enter at your own risk."

❧

Beethoven's only opera was *Fidelio*, which *The Concise Oxford Dictionary of Opera* calls "an uneven but magnificent expression of faith in liberty and loathing of tyranny." In it, a woman infiltrates a prison in an attempt to free her husband. On her urging, a group of men comprising the "Prisoner's Chorus" are led out into the sunshine for fresh air. They sing what has been described by NPR as "some of Beethoven's most radiant music."

According to my father's book, the opera is often performed at houses that are being reopened "after destruction or enforced closure due to war." This association with war began upon *Fidelio*'s very first performance, during which French troops were marching on Vienna.

The war that is Detroit is not yet over, nor has it been officially declared. But *Fidelio* was performed at the Detroit Opera House in April 2013.

❧

In the bathroom, a woman helps me put on a bulletproof vest and says of her lieutenant, "Listen to what she says. She's always into stuff." She pulls at the Velcro so that the vest fits tight against my body, emphasizing words that I should keep an ear out for. *Duck. Cover. Run.*

The stories that my cousin told me before the ride-along could have come straight out of *The Concise Oxford Dictionary of Opera*:

Castrato. A woman protecting herself against the swinging arms of her brother picks up a knife and raises it toward him blindly. He falls dead and blood blooms underneath him, from what wound they cannot tell. When the heavy corpse is lifted for removal, the man's scrotum remains, sliced clean off his body.

Chorus. A stolen car slams into and is wrapped around a pole. The driver's head is found in the street. After hours of searching with a helicopter and a fire truck, the body is found on the roof of a store. Someone sends a text message with a picture of the disembodied head to the victim's father, as though it were some kind of joke.

Crescendo. A naked man sets out in the direction of the Ninth Precinct office, holding an infant. He kills the baby and drops it along the way, as he is walking. Biblical proverbs are found written in blood on the walls of the home he has left behind, along with the body of his wife.

I try to imagine how I would react to each scenario as I reach for the soap in the bathroom. The dispenser is empty.

At the department's morning meeting, my cousin stands at a podium with her glasses down on the tip of her nose. "Name of the game is we back each other up, back each other up, back each other up." The officers stand facing her, in two rows. "Anything from the line for the good of the all?" she asks, and pauses. No one responds. She requests that an officer, a friend from her childhood, lead the troop in a prayer. "Dear Lord," he says, "let us come back in one piece. Amen."

She lists off the crimes that took place the day and night before. Shootings. Arson. Cocktails. I'm assuming Molotov. "Sweetie responsible for that," she says, lowering her glasses and looking at the officers for emphasis, referring to a recurring somebody whom everybody already knows.

"Possible homicide. Man named Fred Young," she says. Upon pro-
nouncing the name of my grandmother's friend, she looks at me and
nods. When we walk outside, the garbage truck tumbles past us. The
parking lot smells of rot. Apparently, when the incinerator across the
street is burning, it rains trash.

❧

According to *The Concise Oxford Dictionary of Opera*, opera has been
performed in Detroit since the mid-nineteenth century, "when sea-
sons were given by the Pyne-Harrison and De Vries Companies,
and by an Italian ensemble under Arditi."

One winter, some year I can't quite remember, my family and I went
to Greektown for dinner. Our waitress, most likely in her sixties,
was short and round. She wore a tight bun and sat in the back of
the restaurant, smoking a cigarette while we looked over our menus.
Handing us our food, she had the grace and voice of a person who'd
lived a big life, a quality my father can detect like a drug dog. I'm
sure he asked her a question, but I remember their interaction as
more accidental than that, as though without any kind of prompting
the two of them began chuckling quietly about the personality of a
Black soprano whose voice they both admired. She herself had spent
much of her life as an opera singer. The rest of the night echoed a
little deeper after she left us to our avgolemono soup. When we went
back to find it the following year, the restaurant was gone. Because
the casinos that light up the street offer free food, many of the historic
Greek eateries have been forced out of business.

Not far from Greektown, where Woodward meets East Jefferson at
the river, you will pass the statue of a seated man with his arms ex-
tended, *The Spirit of Detroit*. The man is muscular and cross-legged,
made from oxidized copper. In his left hand he holds a golden orb
with rays shooting out of it, and in his right he holds a golden family

with upraised arms. The plaque states, "The artist expresses the concept that God, through the spirit of man, is manifested in the family." But you would be forgiven for thinking that he is holding the orb of light up and away from them, just beyond their grasp.

D is for Dresden, where Wagner was appointed Royal Saxon Court Conductor one hundred and two years before the city was bombed. *D* is for "Dance of the Hours," a short ballet in *La gioconda* (and later, *Fantasia*) "in which the eternal struggle between darkness and light is symbolized."

◆

Our squad car makes a faint whining sound when it's started, so we switch to another. This one has no cage to separate the back seat from the front, but it's the better of the two. There are a cherry-scented air freshener, a Cheetos wrapper, and a blue Bomb popsicle wrapper stuffed into various pockets and creases of the car. I am struck by the way the belt and glint off cuffs make male officers walking across the parking lot look so feminine, accentuating the natural twisting of their hips. "That's the Morality Unit," my cousin tells me, which means Vice, which means sex work. When she pulls on the panel with the lock and window buttons on the door of the five-year-old patrol car, the entire thing comes off in her hand.

"The car radios don't work, so if something happens to me, pull up this radio and start talking." She grabs at the radio attached to her uniform. Sensing that this information has freaked me out a little, she adds, "I'll try not to misbehave today." Given all the stories I've heard and all her bravado, I am surprised to learn that in over thirty years, she has only ever fired her gun at a firing range. She avoids using her baton, too. As I yank at and click in my seat belt, I glance over at her and notice that she's not wearing one. Feeling my gaze, she announces, "They're not gonna find my body shot up trying to unbuckle."

Our first task of the day is to back up two officers responding to a call about a twenty-seven-year-old with an AK-47. My cousin tells me that because of laws intended for rural Michigan hunters, it is perfectly legal for an eight-year-old child to carry a gun in the street, so long as he or she is accompanied by an adult. We scan the streets for a man who is five feet six, wearing a gray shirt and jeans. As we pass by the location he was seen departing from, the girl who made the call is standing in the doorway of a nondescript apartment building, wearing pajamas and glasses. "She's mad at him because he took her keys." There is something nerdy about the girl, maybe because of the green belt hanging off her pajamas. The idea that she was just close to an AK-47 puts the whole concept of an AK-47 in a new light for me. I try to imagine the way this kind of weapon will look, angular in what I imagine to be a flimsy drawstring backpack. We search for a figure darting through alleys, or walking in broad daylight, or hiding next to a dumpster, but find no one. Small blue flowers proliferate on the lawns we drive past, and I remark on the color. "That's probably the state flower in some other country, but here it's a weed." One family has assembled out in front of their house to pull up the weed, and their efforts are surprisingly arduous considering the delicate shade of their pale-blue enemy. At another house, a woman with a yellow shirt and pigtails is combing her hair out on the porch.

"We all get up in the morning, come outside, and comb our hair," my cousin narrates, mockingly. At the sight of a woman walking down the street, she says, "Out here, thirty looks sixty."

She doesn't expect much action this morning, not until around one o'clock, when more people will have gotten out of bed. Still, the failed search has raised my adrenaline significantly. I am no longer curious to see anything extraordinary happen. I just want to get home alive. A man in an open blue dress shirt bikes through the blue weeds, scowling at the cop car.

In the years since, as I've wept at the sight of Michael Brown's body and Freddie Gray's body and Eric Garner's body on the news, I've wondered about the story behind that glare, and all the other stories I was not told that day. I think often about how my white cousin negotiates the question of race when violence plays out in front of her, or on the news, since she herself has a half-Black son.

●

I am told to keep track of street names. Lansdowne and Morang. Kelly and Moross.

Two attractive, clean-cut young men, one white, one Black, stand in the street, in the middle of a transaction they make no attempt to hide. They watch us pass with smirks on their faces. "Dope," my cousin tells me. She does not slow down. "There are some things you don't do alone."

We pass a Valero station where my cousin once arrived to discover a man who had been shot in the entrance of the store. As he lay dying, his head was struck by the door each time a customer stepped over him to enter and exit, carrying on with business as usual. "Shut off the pumps," my cousin announced, infuriated, to the clerk when she walked in. Pacino-ish in the retelling.

We are on Cheddar Avenue, which is pronounced *chedda*, which means money. "Whatever the fuck you want you can buy on Cheddar Avenue," she tells me. She pauses in front of a house decked out with balloons, T-shirts, candles, and liquor bottles, which serve as a memorial for a group of people who were recently killed. "That's a rip kit," she says. "RIP, rip. One officer joked that he wanted to sell them at shootings." She pauses, chuckling to herself. "I know. That's sick."

Someone has called to report a vandal in the process of stealing aluminum siding from an abandoned house.

Chalmers and Elmdale. Chalmers and Maiden. Chalmers and Hayes.

"Nobody pays rent there, I'll guarantee it," she says as we drive past a series of apartment buildings. "Those assholes were shooting at us the other day."

On a well-maintained residential street, we pass a minivan that has been completely stripped. It looks like a war victim, no wheels, no nose, caved in and lopsided. A pit bull meanders down the block, wagging its tail.

●

In the documentary *Searching for Sugar Man*, folk musician Sixto Rodriguez walks down a street in Detroit, sun setting tangerine behind his slouching body. One of the most beautiful songs in his repertoire features his aching voice singing of the drug dealer who sells him "silver magic ships" and adds color to his dreams. Jumpers, coke, and Mary Jane act as the cure for his lost heart, false friends, and his lonely, dusty road. "Sugar man," Rodriguez sings, "you're the answer," his voice lilting, "that makes my questions disappear."

More than a few operas revolve around the theme of elusive pleasure.

Faust sells his soul to the devil in exchange for a little youth.

Hansel and Gretel are sent to the woods to gather strawberries as punishment for playing, and instead of bringing the fruit back home, they lose track of time devouring them.

In *Irmelin*, a prince named Nils follows a silver stream, convinced that it will lead him toward true love.

It is impossible to talk about Detroit without talking about intoxication. At dinner one night, we go around the table making toasts. When it's her turn, my cousin says that if she could stop one thing in the world, it would be addiction.

In the squad car my cousin surprises me when she says, "You wanna buy any kind of dope? Go to that gas station." I turn around, squinting back at the station in question, working hard to dismiss thoughts about a very stupid adventure involving a dime bag of weed. As if she can smell the curiosity on me, she adds, "Wanna get robbed or shot? It's gonna happen there too."

●

My cousin's first death on the job was at a hospice, due to cancer. Her second was a man on a couch whose body she saw out of the corner of her eye, perhaps because she was unwilling to face him. Her third was a stabbing, at which point she took out her flashlight to better see the wound. "I got braver," she explains. The first shooting she witnessed "blew my fucking mind." The most recent death was self-inflicted. "My horrible," she says, "is the nephew and the brother looking at the body."

When she started on the force, her brother told her, "Don't let them make you something you're not." And she took his advice to heart. Instead of going out to drink after a shooting, as is the tradition for many of her colleagues, she goes home. She has joined them maybe once in her entire career. If only every officer had a brother like Ralph.

At the house we have come to investigate, there isn't a trace of a vandal. We walk through to the backyard, examining the place the siding

has been taken from. Stealing off of abandoned lots is a kind of home-and-garden pastime for Detroiters of all backgrounds. You can have some marble from the Packard plant for your end table, replant some long-gone woman's rosebush in the front of your house. Everybody does it. When he was young, my father helped my grandfather collect scrap metal to sell. But this was done with the owner's consent.

A cat meows as it enters the house next door, whose entire front has melted and where trees are growing out of the windows. Across the street, a man trims his hedges. He has no idea who might have called the cops. This does not mean he wasn't the one who called, though. The graffiti and billboards in this city shout back and forth as if in a family argument, declaring the pros and cons of snitching.

We meet up with two other officers, both women. The conversation is idle, quiet, meandering. I feel like I am back in first grade, on the playground, playing make-believe with a couple of friends. We stand facing the charred and melted house and discuss the whole vegetation issue in this city. "See that?" my cousin asks me. "That's not a tree. That's a weed." She is pointing to the tallest plant near the house, a skinny, wild thing, but wide and high enough to be mistaken for a legitimate tree.

The degree to which the abandoned house has been overtaken by greenery verges on the magical. It reminds me of movies about children growing up in the South, spending days investigating floor after floor of old barns and farmhouses. Except, in these films, there aren't two men breathing heavily behind the side door, hands calloused from ripping at the aluminum siding, waiting for the cops to leave.

One of the policewomen who has come for this call kicks at a tree stump. She has puffy neon stickers on the butt of her gun. We pile into our respective squad cars and go.

●

One night, on the front steps of our house, my cousin told my mother and me some of the most incredible stories we'd heard yet. In one, a man picks up and flings an eighty-year-old man onto the sidewalk before stealing his gold. The "gold" is the necklace of the old man's recently deceased wife, the loss of which hits him much harder than the beating. A woman who watches this scene play out chases after the assailant, but he disappears into a field of tallgrass. "People are tired of this shit," my cousin said, laughing at the tenacity of the bystander who seemed so bent on bringing the fugitive to justice.

Sometimes we worry about her. That all this extremity and violence has hurt her more deeply than she's willing to admit. The stories she jokes about are sometimes so horrible, it seems impossible to summon a polite smile in response. My uncle, a retired psychologist, explains the necessity of laughter when it comes to Detroit. Without the humor or beauty that might be found in these moments, such jobs would be completely unsustainable. But jokes can only soothe so much.

One day, after a home visit that rocked him badly, my uncle drove to Lansing so that he could get out of his car and scream.

In *Jenůfa*, an opera in three acts, the body of a child is found underneath the ice.

When this plot played out on my cousin's watch, counselors were called to talk with the officers involved. My cousin was the only one to speak at the baby's funeral.

●

Somebody has broken the window of a parked car. A husband is trying to explain what happened through the thick haze of alcohol,

which he denies having consumed, emanating off his body. The choreography of bodies is careful. My cousin, like a director maneuvering an actor on stage, tells the man to call for his wife and to come out of the house, but when she appears and he moves toward her, my cousin warns him not to go near his wife, using his first and middle name as though he were a child. His wife has the face of an exotic animal tattooed onto her arm, its head bent back in some kind of scream. Husband and wife both make attempts at constructing a narrative. Liquor makes his version a lot harder to follow.

"Whatever you had to drink, make sure it don't take you to jail," my cousin tells the husband. The husband's drinking buddy is still sitting on the porch of the house. Without opening her mouth, my cousin looks at him and points, and he doesn't miss a beat, hustling down the steps. A toddler has wandered over to us from the porch full of watching next-door neighbors, and my cousin picks him up and delivers him back to them, scoldingly. Eventually, she gets the wife to go back inside so they can speak in private.

"C'mon, little Jess," one of the officers says as she passes, ushering me toward the house. Inside, the same animal that was tattooed on the wife's arm is everywhere. My cousin is waiting as the woman cries. I lower my eyes as she releases her story to a room full of listening women.

"That is mostly what your job is, huh?" I ask later. The capacity to listen and observe more than to bully and corral. "Yup," she says. Her branch of the family is known for being perceptive. Verging on telepathic.

"Don't disrespect your wife in public," my cousin tells the husband as we get ready to go. "Then you won't have to kick their ass if they disrespect her."

"I like you, you a good person," he says, still merry with drink. The other officer recommends that he take up fishing, and he laughs. His drinking buddy, hovering near the scene harmlessly, turns to me and begins to ask if I'm in training. I nod my head, tight-lipped, and move past him toward the car.

"That marriage is over," my cousin pronounces as we drive off.

My cousin will tell me in the squad car what had been whispered to her in the house. The wife in question was threatened at gunpoint at a fast-food restaurant around the corner some time ago. Ever since, she's been on heavy medication, which keeps her sex drive low. This pisses off her husband, who has started to drink, and to flaunt his sexual exploits in front of her. "I won't give him any P-U-S-S-Y," she kept whispering. My cousin is positive that this is not the last we'll hear from this address today.

●

As we drive past a crisis center with a crowd of people in front, a man flags down the squad car. We back up to see what he wants. He has zebra-style shaved eyebrows, and asks my cousin for a light. "Are you fucking kidding me?" she asks him. We speed off. We are heading toward the foot of Alter Road, to the river.

"That was a bad mama jama," she says as we pass former mayor Coleman Young's old party house. For many Detroiters, this is a kind of epicenter of Detroit's downfall.

The neighborhood we move through en route to the river has a southern feel about it. "Like you fell off into Arkansas," my cousin says.

The lighthouse near Alter Road is a favorite spot for suicides. A five-hundred-pound woman jumped one winter, and officers waded into

the subzero water to get her out. The fishermen tense up a bit as my cousin slams the door to the squad car and approaches. A while back, when she got wind that one of the cops in the squad was on his way to ticket the fishermen for fishing without a license, she beat him to the waterfront and warned them.

I catch a glimpse of myself in the reflection on the car window. I look boxy. My hair is in a tight bun. I feel as though I'm in costume, and walk for some reason as though I am a robot. I am terrified that someone will require me to speak, and I gaze off into the distance so as to look preoccupied. We approach one couple in particular, and my cousin asks them about their luck that day. There is no crime being reported here; the river is just a place where my cousin likes to be. But nobody knows that except for me.

As she talks about her fishing exploits, her philosophy on the psychological benefits of fishing, a man listens politely, holding his fishing pole, perhaps waiting to find out what it is that he's done wrong. Other folks farther down the way crane their necks to see what's going on.

The fisherman is accompanied by his vaguely high wife. She tries, like a double-Dutch player, to jump into the conversation every chance she gets. But my cousin is waxing poetic: The ugliest fish she ever caught. The fact that she catches them and then gives them away. Sometimes she just throws them back in. I stand in silence, watching the man, wishing he were as at ease as he meant to be when he woke up and thought to head for the river.

◆

On a trip to Bavaria once, I went on a tour of King Ludwig II's castle. There was a cave with a small pond at its center, which held a boat. A lover of opera, fervent patron of Wagner's, King Ludwig would, from this boat, act as the sole audience for elaborate musical

performances. Lit with red and green lights, the cave seemed an eccentric kind of loneliness. At the time, I scoffed at the extravagance of it. Now I wonder about the feeling of an orchestra quivering to life inside all that scooped-out stone and sorrow.

My father told me recently that the first novel he ever read was *Of Human Bondage*. Around that same time in his life, he had a paper route that took him past Goethe Street, which everybody pronounced *go-thee*. The word has come to symbolize the smallness of the universe he grew up in. Something he was aware of from a very young age. Years later, he studied German authors, walked the streets of Frankfurt and Berlin, and learned how to pronounce Goethe correctly. Some days my vision of him flickers and he is still that child, murmuring his way through the unfamiliar expanse of a novel about feeling trapped. He's always said there should be an opera written for Detroit.

At the Heidelberg Project, Tyree Guyton's outdoor installation of found materials—boots, religious iconography, whole houses, shopping carts—my father is taking pictures of a pile of doors. I turn on the classical station and play it loudly for him out the open windows as he engages with the art and the wreck.

When I reach the words *Magic Flute* in *The Concise Oxford Dictionary of Opera*, part of me feels a flutter. As if the story of this city could be armed with some aura of the fantastic, like these operas are. Will Detroit ever be imbued with secret power? Even I am lured into the possibility. That an instrument in the tallgrass will lead this story toward its resolution. Set the dead man back to standing.

As if to mock my anticipation, beside the entry the dictionary instructs: See *Zauberflöte*.

●

Southampton and Ashley. Gratiot and Seymour.

A fifteen-year-old boy has been hit upside the head with a baseball bat. En route, we pass a public school, and my cousin tells me that even though the student body is getting smaller, the Detroit Public Schools Community District's police force is getting bigger. When we arrive at the scene, EMS is there. It is apparent that this boy is older than fifteen. The man in uniform outside the ambulance is pacing. As we walk past, he is saying into his cellular phone, "She seems mad I haven't picked up the mail."

My cousin asks questions rapidly as if simultaneously gathering information and keeping the young injured man conscious. He is tall, crouched in the vehicle with the other EMT tending to his head. His elbow is bleeding. As the story goes, a man with dreadlocks hit him on the head with a bat while he was walking across a gas station parking lot, and someone started kicking him in the head and face. An anonymous black Cadillac pulled up beside him and drove him to this address.

"You can't imagine why someone woulda done this to you?" she asks. No. "If we locked him up, would you tell a judge and jury, *This is what he did to me*?" No. I wonder from the boy's manner of speaking whether or not he might be gay. He coughs. "You smoke?" my cousin asks. No. "Do you have asthma?" He shakes his head incessantly.

●

When I am visiting with my father, I will often find him watching a YouTube video in which an audience is told that Pavarotti will not be performing that night. A good friend of his will be onstage instead. At which point, with the crackling warmth and smoke of a fire, Aretha Franklin starts to sing "Nessun Dorma." My father begins to laugh and shake his head.

His best friend, Rodney, is an avid fan of old movies. He is often quoting films from the forties and fifties. He was the kid who wore the five-hundred-dollar suit he bought cheap from a thrift store to play in a pickup basketball game.

The difference between their generation and the one coming of age in Detroit today, at least on the streets where they grew up, seems to have to do with a lost capacity for dreaming, for anticipating the unimaginable. There is no longer the same swagger that made Motown. No energy for revolt.

And yet. One afternoon, as a friend and I drove down Jefferson, a man with long dreadlocks was skating with all the grace of a ballerina, headlong into traffic, swerving assuredly between oncoming cars.

The *O* section of *The Concise Oxford Dictionary of Opera* begins with a long list of laments. *O Carlo, ascolta. O cieli azzurri. O Isis und Osiris. O luce di quest'anima. O terra, addio.* Some are appeals. Some are love duets. Others are about a star, a death, a god, or a place.

O patria mia, Aida sings. O country of mine.

●

"I need to put them on an island," a hostage negotiator for the police force tells me. If he's not the only one communicating with a person on the verge, his work is compromised. Once, a man at Chene Park with a gun to his head spent five hours not killing himself or anybody else. But his phone kept ringing. Finally, he picked it up. He told the person on the other line, "I love you," and shot himself. The negotiator was standing ten feet away.

"There's an art to figuring out what's going to happen," a recently retired officer explains. "We didn't have a winter this year. Just spring,

summer, and fall. And I hate to say it like they're animals, but they never rested."

The current economy paired with a poorly educated population "makes it easier for loosely knit people to commit crimes," he says. And then there are the people who wear the badge. "You get a broke cop, in over his head, bad mortgage . . . soon they'll be able to get food stamps. You can go to McDonald's and get better benefits." In 2016, two officers were convicted of plotting to sell drugs and money that they had seized during raids. The more taken away from officers' pay, the more likely they are to dip into crime themselves.

My cousin takes me to lunch at a restaurant with big black-and-white photographs of historic Detroit framed and centered on the wall beside the booths. Two officers join us. Over french fries, coffee, and Greek salad, they lament the various aspects of a failing department.

How a robot answers the phone when you call 911 after dark. How somebody's idea of a solution is that during your first year as a police officer, you work for free. How badly they feel for the firemen. How they suspect that, with the city getting a percentage of the profits made by the Tigers, the Lions, and three casinos, Detroit might not actually be broke. How camaraderie among officers is gone. And trust. How they used to love their jobs, and now they don't.

This is something that hasn't improved much since the bankruptcy. Officers starting on the force in Detroit make about half of what you can make at the same job in Los Angeles—less than fifteen dollars an hour, after taxes. After it was announced that, as part of the post-bankruptcy plan, the force would endure a 10 percent pay cut, the Associated Press published an article about a police officer named Baron Coleman who was consoled by the people he was arresting. They said, "I can't believe your city would do you like this."

●

Some people like to say that Detroit is going to seed. Reindeer have started to follow the train tracks into the city. Peacocks from the Detroit Zoo can be found parading down the streets of the nearby suburbs. Whole families of quail and pheasants huddle and march through the empty lots that human families have evacuated.

A few days after my grandmother's funeral, we made an impromptu family trip to the Packard plant, the same way we would go to a gallery or museum. Wandering through the halls of what had once been a major source of strength to Detroit, I took pictures of my father as he raised his camera to the decay. We stepped carefully up the once-marble staircases, read spray-painted messages and stencils as we would the captions beside paintings. We looked out over the expanse of that historic crumbling through huge holes that seemed to have been blasted into the wall.

Entire rooms glowed pink and green and yellow and blue as the sun seeped through fluorescent graffiti painted on the glass bricks. Archways led into rooms where rebar hung from the ceiling, like an upside-down field of falling knives. In one room, I took video of the sound of dripping, of the birds that huddled and swooped through the pale, gaping interior. We peered down empty elevator shafts, as if into some underground world.

Goethe wrote a version of Proserpine for his sister. Stravinsky made the music. Martha Graham set the myth to dance, as did Pina Bausch. In Bausch's rendition of *Le sacre du printemps*, another story about a young girl who is sacrificed in the name of spring, the stage floor is covered in dirt. A red dress serves as the only thing of vibrant color, carrying the eye as it is passed around from body to body, then tossed onto the ground.

On the last day I spent with my grandmother, I happened to look across the street, and caught a glimpse of something in the grass. It was an adult pheasant, feeding as his head feathers glinted red in the late-afternoon sun.

●

We get a call about a stabbing. The call has come from the same address as the domestic dispute we visited earlier in the day. "We're gonna see who got cut," my cousin says as we swerve onto the freeway on-ramp. When we pull up, the wife is standing on the curb with white cream on her face. "Noxzema face," my cousin mutters affectionately before opening the door. "What's on your face?" she says as we get out of the car.

A group of neighbors speaks with an attractive female officer whom my cousin calls Malibu Barbie. One man says that he observed the struggle and screamed for the husband and wife to stop, but didn't want to come close because he could see that somebody had a knife. He isn't sure who hurt whom. As Malibu Barbie walks away, he looks appreciatively at her behind and the people standing with him begin to laugh. Her beauty is about on par with Beyoncé's, and the incongruity of this given the grim scene makes me cough up a weak chuckle too.

"I told you I wasn't coming back here," my cousin tells the husband, who clings to his injured arm. He is no longer a fan of hers. "You wrong," he growls. "I ain't got to talk to you," he shouts. "That's another charge," my cousin says.

Inside the house for a second time, I notice that everything is green. A large photograph of a young man who shares his father's name is sitting on a mantel. I try to make small talk to get the woman to

explain the animal whose effigy I see knit, carved, and stamped into every piece of available space in their house. But, understandably, she is unable to concentrate on my question. "I don't want to go to jail," she tells me, "but I'm afraid I'm going to kill him."

When it's time to tell her side of the story to my cousin, she shouts it. We find out that she was trying to take a bath when her husband tried to have sex with her. She resisted him and he locked her out of the house. He had already taken the battery out of the car, but now he hid the keys and her phone, so she had to go to a neighbor's house to call the police.

"That's another charge," my cousin says.

I wonder what would happen here if the officers weren't all women. The wife swears that her husband cut himself. Whatever it is, it's only a scratch.

The whole scene has an unwittingly comic air to it because, as though in costume, the anguished protagonist is still wearing facial cleanser. But nobody in the house thinks any of this is a joke. The police-women assembled seem to have taken a special interest in protecting the woman who lives here. They articulate her options clearly and repeat them. Her husband, whose drunkenness has indeed worked against him, is going to spend the night at the station jail. Hopefully, my cousin says, they'll get a restraint against him.

"Mississippi and Alabama don't mix," she says as we drive off. She points out her window, to where a house is facing backward, toward the alley.

●

Back at the police department, my cousin's phone rings. The song "Boombastic" by Shaggy is her ringtone, and she begins to dance.

Earlier in the day, in this same spot, a male officer took notes as a fourteen-year-old girl explained how she'd been forced into an abandoned house and raped.

In *Die Zauberflöte*, Mozart's *The Magic Flute*, a man who seeks enlightenment discovers an instrument that can turn sorrow into joy.

When I think of the woman who could have killed her husband, I think of the wild animal tattooed on her arm, the way her house was filled with those tiny figurines. I wonder about that moment, long ago, before everything fell to shit, when she realized that this animal gave her some sense of strength and that, one day, she'd need to be reminded.

One American Goes to See *30 Americans*

The *30 Americans* exhibition on view at the Detroit Institute of Arts from October 2015 through January 2016 is an extraordinary opportunity to see the work of some of the most important contemporary artists practicing today. Everyone who can see it should. Take your nephew. Take your grandmother.

Carrie Mae Weems brings some Susan Sontag–style *Regarding the Pain of Others* analysis to a series of slave daguerreotypes. In a small screen in the corner of a room, Pope.L crawls along the sidewalk in a Superman costume to inspire someone, somewhere, to think about the lived reality of houseless people. Iona Rozeal Brown helps us navigate our complicated feelings about the fact that sometimes, Japanese hip-hop artists wear blackface. Kara Walker still wants you to go ahead and try to act normal in front of one of her murals. Just *try* to smile politely at a stranger while you are standing in front of one of her murals. Hank Willis Thomas does not seem like the kind of guy who thinks that Black athletes, by being rich, negate questions about branding and ownership. I have loved so many of these artists for so long. Kehinde Wiley? Kalup Linzy? Lorna Simpson? They deepen our conversations about race and gender and violence and value when we direly need to do so. Etcetera, etcetera.

This is not what I've come here to talk about.

As I listened to the audio tour narrated by Touré, I felt a few things. First, I was underwhelmed. I mean, I loved Touré's profile of Lauryn Hill in *Never Drank the Kool-Aid*, but it's not like he would have much creative control over this audio tour. Many snippets involved student responses to the art, when I wanted to hear more from the artists themselves.

Let me preface this by saying: I wasn't in a great mood. It was the Tuesday before Thanksgiving and I was visiting my family— transitioning to a midwestern winter climate from a desert "winter" one. When this happens, I forget how to exercise and I have no idea what to eat for breakfast. Upon entering the museum, my father and I got into a minor scuffle with one, then three security guards over whether or not my dad's selfie stick was indeed a selfie stick if he thought it might be used as a "unipod." I hissed at him, "Don't make a scene," and then I realized from the way they were looking back and forth between me and my dad that the security guards weren't so much comforted by my presence as they were invisibly sucking their teeth at this coddled biracial kid who didn't know how to respect her elders. Somebody looked scared—like she was shielding her son's body from us. Also: there were about five hundred student groups that day. I kept doing that thing adults do in the face of adolescent swagger, where you act like you're so above it and then you stumble into something.

As we got our tickets, my dad nodded his head in my direction and joked, "She's five," as if this might get me a cheaper entrance fee, but also in a way that, in retrospect, may have been revenge for me not siding with him in the selfie stick situation. Then, a woman told me, with very intense eyes, that I looked *just* like Frida. I love Frida Kahlo, but do you ever feel, when a white woman gives a young Black woman a compliment with a certain expression on her face,

like you can hear the soundtrack to *The Help* playing in the distance? Or, I don't know, *Out of Africa?* I WAS IN A BAD MOOD. The holidays are a tough time to release your inner child into the meadowlands of Black conceptual art. I tried to eat a root beer–flavored taffy, but my inner child stayed put. Maybe I was looking for a fight.

On Facebook, I was about to the make the mistake of engaging in a racially charged comment thread. I would actually have to post that Thanksgiving Adele *Saturday Night Live* video in a gesture of peace. More globally, though, in about twenty-four hours, a white supremacist would be shooting five Black Lives Matter protesters in a city I always thought of as exceptionally tolerant. Paris happened. Beirut had happened. Donald Trump existed. There was something in the air.

So, as I walked through the exhibition, I started to wonder: What exactly is it about this show that feels funky? There was a missing context. It felt, somehow, opportunistic. Vampiric in a way, as if the premise was, simply: Black is hot right now. But that couldn't be it—not realistically. Shows like this take a long time to plan, and this was a traveling exhibition that only just now had gotten to Detroit. The Black Lives Matter movement wasn't even a glimmer in Patrisse's or Alicia's or Opal's eye when the show came to fruition. So why was I not convinced?

Something flickered for me around the time that, in my earphones, one of the collectors who'd put on the show, Mera Rubell, asked Shinique Smith about her piece, *a bull, a rose, a tempest*. The work consists of a collection of items—a shoe, a bag, some kind of camouflage fabric—hanging from the ceiling. When something hangs from the ceiling like that—lumpen, hog-tied, reminiscent of a body—there is a visceral quality that makes you want to spend some time alone. In the interview, what Rubell decides to ask is, "Do you go to specific places to get these rags?" And Smith responds, "I don't really call them rags."

Now, the kind of frustration I feel toward Mera Rubell's interview style isn't on par with, say, the frustration I feel toward Ted Cruz's affiliation with a homophobic pastor. The Rubell interviews hold many moments of racially complicated dissonance, similar to those Facebook arguments you might have with somebody who does not seem to have encountered *any* race theory or even considered the possibility that there might be some literature to read up on before diving into that Meryl Streep suffragette T-shirt kerfuffle. Just, like, five minutes of bell hooks. The frustration I feel toward Mera Rubell's interview style is rooted in the experience of listening to someone who holds a lot of power, whose title is "owner," who makes inquiries she doesn't care to hear the answer to of people whose intelligence is tripped up and cornered by the mediocrity of the questioning.

In *America*, Glenn Ligon's neon sign, the tubes are painted black, while the light is bright white. The effect is that the lettering is outlined, limiting the incandescence. Rubell says, "This piece—you wouldn't make this piece today." She says, "Somehow this piece is a pre-Obama moment." When somebody says "pre-Obama," I don't feel far from the word "postracial." Ligon explains that the piece was inspired by Charles Dickens. When he says, "It was the best of times, it was the worst of times," Rubell joins in. Yup. He continues,

> *I started thinking about the moment when we went to Afghanistan, thinking how interesting it is when they go to Afghanistan, these reporters go and they interview people on the street who say, "Your bombs dropped here and killed my brother and destroyed our house and I want you Americans to live up to your ideas of democracy. We believe in America." And I thought how interesting is it that America can be this dark star, death star, and also, at the same time, this incredible shining light.*

At a literary conference in 2015, Eunsong Kim gave a talk about the trials and tribulations of Carrie Mae Weems and her series *From Here I Saw What Happened and I Cried.* Apparently, Harvard University

threatened to sue the artist for using the daguerreotypes of enslaved people originally commissioned by Louis Agassiz because Harvard owned these images. Kim challenged the audience to think about the question of ownership here, given that the images themselves portray the bodies of slaves. When encouraged by Weems to have this conversation out in the open, the university declined.

My sweet father purchased, for my spoiled ass, *The Conversations*, a DVD about the *30 Americans* exhibit including extended interviews with the artists, and I have been watching with my face contorted into a grimace, the way you would watch, perhaps, *Khloé and Lamar*. Or certain episodes of *The View*.

Some artists do a beautiful job of owning the awkward room into which they have been beckoned to perform this chitchat. I say "perform" and "chitchat" because these interviews feel perfunctory rather than curious, contained and at times corrective when the artists have so much more to say than the space knows what to do with. If you want to know what the subtext of these interactions looks like, check out Rashid Johnson's *The New Negro Escapist Social and Athletic Club (Thurgood)*, in which a Black man stands with an expression of utter imperviousness as smoke rises around his Frederick Douglass–style hair.

I give credit to Jennifer Rubell, the daughter of the collectors, for editing the video in a way that tries to honor the manner in which these artists assert themselves. The film begins with Kerry James Marshall energetically questioning the concept of power. "There are no Black collectors that I know of that can do what you just did in having an exhibition like this," he says to the collectors' faces. And, "How much analysis, how much criticality, are you bringing to the essays in the catalog?" He goes on to say that the title of the exhibition, by avoiding mention of Blackness, feels like a lie: "You've tricked them into coming here."

After we leave, my father and I get some hot and sour soup. We visit Dell Pryor's gallery on Cass Avenue, where the work of Kara Walker's father, Larry Walker, hangs on the wall. During Thanksgiving dinner, my (white) mother will ask my (Black) great-aunt if she is tired. To which she will respond, "That's why the white man don't let the nigger eat until after he works the field." The room will be quiet for the smallest second before exploding into laughter. It always fascinates me that in the humor of this ninety-four-year-old woman, the antebellum era exists in present tense. The owner and the slave and the field as clear as day.

Dreaming of Ramadi in Detroit

When we get to the Dallas airport, the televisions are showing a headline about a hunter who paid hundreds of thousands of dollars to kill an endangered rhinoceros. It makes me feel a screech inside, a smearing. "Don't look," Hannah warns me, but I keep erupting in puffs of indignity on the escalator. At the gate, I cry at the end of the Das Racist song "Rainbow in the Dark," when Victor Vazquez says, "Tried to go to Amsterdam, they threw us in Guantánamo." Then I play it over again so I can trip back into my cry.

As if on cue, CNN reports that a bunch of bin Laden's documents have been discovered. Bin Laden reminds me, in one clip, of a boy I went to college with, whose eyes were huge and kind and beautiful like a superpower. There is room for empathy in the reporting, which I find a little terrifying. These news anchors have been given this kind of permission, or the order, to humanize what once was our monster. The "why" behind these gusts of change in media seems just as disconcerting to me, sometimes, as the news itself.

The anchors highlight bin Laden's anxiety that his followers might create a caliphate. That he loved his children. The word *achingly* is used. They speak of love letters to his wives. His fear of drones. It reminds

me of that weird swoon of time when I couldn't stop watching *Homeland* because of the feeling of vertigo I got when the kind-eyed terrorist lost his son to a drone. Tonight, I will dream that I live in a city like the recently captured Ramadi. We have to make deals with the soldiers, who hold items on a pillow as we haggle for our lives.

The last time I flew into Detroit, I saw a famous man whom I thought was Delroy Lindo. Airport employees came up to him, held his shoulder, joked with him. On screens, CNN was reporting the non-indictment ruling in Missouri and I felt a special honor to be watching with this famous Black man those first reports from Ferguson, when Ferguson *became* Ferguson, as Michael Brown's stepfather shouted "Burn this bitch down!" into a crowd.

On the plane, I sat across the aisle from, as Percival Everett might call him, Not Delroy Lindo, who was, nonetheless, *somebody*, and an engineer was called onto the plane to fix a piece of ceiling that was popping off in the corner. After what felt like an unnecessary eternity of duct-taping, we began to move, and when the plane picked up speed the ceiling actually fell down. The ceiling of a portion of the plane fell down onto people's shoulders, and we screamed "STOP STOP!" But the pilot sitting next to me, because a lot of airline staff happened to be riding that day, laughed and said, "It's much more dangerous to stop than whatever threat that ceiling poses. That's cosmetic." So we lifted into the air and people, unbuckled, stood up to hold the ceiling together, and Not Delroy Lindo chuckled with the girl to his left, and I felt more comfortable with the calamity because he was there. Not Delroy Lindo's scarf fell and I handed it to him, managing not to say, "Mr. Lindo." It was so soft.

On this trip home, I have been texting with my cousin, who tells me that I will not be able to shadow her at work while I'm visiting. It would have been my second time on a ride-along with her on her rounds as a lieutenant for Detroit's Ninth Precinct. So much has

changed since the first time. Namely, I have developed an instinctive sense of terror upon seeing police cars, triggered by the footage of Black men being killed by white officers who lurk in every seam of screen, videos stirred to life the same way that advertisements in the margins come alive when you scroll down or accidentally hover your mouse. But instead of saying FIND A DENTIST IN TUCSON, it's a death showing. A death is showing. Like a pregnancy or a film or some underwear.

Rather than being shot at, my new fear is of seeing officers unleash violence upon a helpless body, having to watch within the confines of my approximated uniform, padded with a bulletproof vest, which would incontrovertibly claim me, identify my orientation as being toward the police and not the helpless body, drown me out even though I can't imagine that I wouldn't be screaming, I am the kind of person who screams. And aren't I? Affiliated? My cousin is my cousin. She's my blood. But so am I Black. My father is Black. She's white. But her children are Black. Our affiliations are bleeding all over the place.

The last time I was home, which was the first time that Detroit functioned as my home-home since my parents moved from Los Angeles last year, my father and I rode to Target together for some groceries. I was writing about Spalding Gray on my laptop as we crossed a stretch of road that only my father would think to take at that time of night, his instincts for navigating his hometown so seamless, and we coasted across the black bridge, the black night, through the black city. On the way back, we noticed the farmers' market blockade separating Grosse Pointe from Detroit along Alter Road, and we were pontificating about segregation as we approached an intersection. The light went green and we started to move and I heard gunshots and saw a house full of people leak into the street—the girl in pink sweatpants hiding behind an SUV—and I said, "DAD, GO. THERE WERE GUNSHOTS. KEEP DRIVING. DRIVE FASTER." But he heard SOMETHING ELSE and so, for the love

of God, we stopped in front of the SUV that was hiding a young woman from a bullet. "GO GO GO!" I shouted, and my father said, "I thought you said to stop," and as we drove farther and farther away we were reenacting the conversation and laughing harder each time. "I was like, 'GO FASTER,'" "And I was all, 'You want me to stop?'" Meanwhile, the scene kept spilling out in time.

At the house, the radio is playing in my attic bedroom to scare away the squirrels that enter by way of a hole in the bathroom. A piece of insulation is reaching through a hole in the ceiling from a rain leak and it looks like a squirrel's reaching arm. Rihanna welcomes me to my bedroom with the song "Bitch Better Have My Money," and I prepare to take a shower.

The night before Thanksgiving, I went downstairs and my cousin the lieutenant was cooking even though she had to wake up at 6 a.m. to go to work, where she would be encountering Ferguson-inspired protesters "who don't even live here." Upstairs, I paced and paced because I was supposed to write something for the Black Life Matters conference when I got back to Arizona. Facebook was ablaze with anger. Every status update sounded to me like a call for my cousin to die. I thought about surveillance and wondered if we were being lured into action by an unseen man in a suit somewhere. I was convinced that everyone's anger would end up benefiting the GOP. I began to write a series of posts that I never posted: "Let's boycott social media!" and "Let's read Noam Chomsky!" and "What if this is the Pentagon's experiment to track the time it takes for a Facebook post to turn into a violent act!" I scream in the face of most things, I guess. But then I watched the video of Eric Garner being strangled and I cried and I couldn't stop for hours.

On one episode of *Da Ali G Show*, Sacha Baron Cohen asks Andy Rooney a bunch of stupid questions, one of which is whether journalists ever put out tomorrow's news by mistake, like election results or

the report of a plane crash. Andy Rooney is apoplectic, he is DONE, and he spits, "How do you know what the news is if it hasn't happened yet?" which I've always taken to be a kind of fatal oversight, the moment when the satirical clouds shift and truth is revealed, like when the rap ends and the song is no longer a sexy joke and the rapper who went to Wesleyan is imagining over top no beat that he could be thrown into Guantánamo when he was just trying to be a stoned hipster.

For my family, Detroit has always been inevitable. It is the place we have been heading back to my entire life. My parents recall White Castle hamburgers and Coney Island hot dogs as if they were the secret to immortality. The city has the beckoning power of a black hole or the Italian countryside or a castle. There is no way to explain our wiring to someone whose fairy tale has always ended somewhere like Florida. Recently, a new friend kept scrunching up her nose when I said my family moved from California to Detroit. This happens all the time. But in this moment it hit me that one of the things that makes no sense when people ask "WHY DETROIT?" with all of their death showing is this presumption that we can choose our homes.

Gray's Anatomy

When I was visiting Los Angeles a couple years ago, I pulled my back. My mother connected me with her former chiropractor. As I stood, I told him what my symptoms were, and in one quick gesture he ripped my pants down, just below the cheek, without a word of warning. Because his eye contact had been spare, I wasn't sure how to make sense of the way he stripped me, like he was going to spank or fuck me. He used a TENS machine and I left with almost no back pain. A bit overzealous, I walked several miles back to my hotel downtown. It's only now that I wonder what else might have prompted that need to wander so many miles by myself.

Later on, I went to see another chiropractor in Tucson after my back froze up again. I waited for what seemed like hours, watching other walk-ins pass quickly through to the other side. I think we were ushered in based on seniority, and I was new to the place, but I kept a close eye on the physical attributes of those who came and went.

The chiropractor listened to my troubles. He moved my head quickly and there was a click in my neck. After a few more adjustments, he told me to come back again, and had the receptionist sell me a multi-visit package. The next day, though I was still in pain, my body refused

to obey when I tried to drive back to claim the appointment I'd already paid for. I turned down a side street and pulled over.

I felt like I could never see a chiropractor again. Because he knows how to break my neck, I'm afraid that he might.

●

When Jean-Michel Basquiat was a child, he got into a bad car accident and they were forced to remove his spleen. As he recovered, his mother, Matilde, got him the book *Gray's Anatomy*, which he memorized.

Art historian Robert Farris Thompson, one of the only critics Basquiat trusted, wondered if the artist's mother, by giving him this book about anatomy, "in a sense, had with affection commanded her son to study his body back together again." Matilde struggled with her mental health. She would sit still for hours and try to "imitate the whistling of birds." When she saw her son's paintings, later in life, she said, "You are moving very fast."

His paintings say "sangre," "corpus," "Diagram of the heart pumping," "cranium," "ear," "eye," "ribs," "skull," "jaw," "armpit," "scapula," "tit," and "elbow." Biographer Phoebe Hoban says of the bodies on his canvases, "Boys never become men, they become skeletons and skulls."

For example, in *Jesse*, Basquiat has drawn a series of bodiless heads and headless bodies. "Neck," he writes just below where the skull would go. "Esophagus," over an open throat.

●

When I used to watch *Breaking Bad*, I felt seduced not despite but because of the graphic nature of the show. I felt devoted to it because

of what it made me see—a perverse brand of intimacy that must explain how brainwashing works in cults and armies. There was one scene I refused to watch because I could tell it would have to do with the neck. I still remember my girlfriend's face in the glow of her computer screen as she saw what happened next.

●

Basquiat's talent seemed to irritate or mystify most critics. In the *New York Times*, Hilton Kramer wrote, "His sensibility, insofar as he can be said to have any, was that of an untrained and unruly adolescent wise only in his instinct for self-display as a means of self-advancement."

In a famous interview, Marc Miller asked the painter of his work, "It's just spontaneous juxtapositions, and there's no logic?" To which Basquiat responded, "God, if you're talking to like Marcel Duchamp—or even Rauschenberg or something . . ." He was such a student of the artists who came before him, read so deeply into history, biology, anthropology, and art, he could see clearly that critics were trying to disavow him of his intelligence. He called himself an art mascot. The vitriol rained on him by critics, the deep well of racism lurking in their response, is as much a part of his legacy as the art itself.

A white photographer who traveled with Basquiat to Europe was astonished by the level of nastiness: "He was treated weirdly, strangely, like he was an oddity. People were entertained by him, fascinated for the moment, but would sooner or later throw him away. Or he was feared, you know? Just genuinely feared." No matter where he went in the world, he was pulled over by the police. In Paris, with guns drawn, the police asked if a woman who had fallen asleep in the back seat of his car was dead.

Actor Jeffrey Wright, who played the painter in Julian Schnabel's 1996 biopic, *Basquiat*, was surprised at how much racism infused

even the telling of the painter's life story: "I really got some insight into Basquiat because I really had to travel through the same doorways and rooms and hallways that he did," he explains. "The mystery you are left with at the end of the film about Basquiat is the stuff that Julian didn't know, so he assumed it didn't exist."

◆

When I was a child, I was a serious gymnast. I stretched often, and deeply. I've long known about my body that there was a resistance at a certain point when I lie on my back and bring my feet over my head. It was a young or ancient part of me that diagnosed this kind of pain, a gray storm cloud of burning, as something I should move toward, not away from. Like bitter greens. Still, I avoided it for years.

Later in life, when I got into yoga, I became reacquainted with that sensation as I stretched the upper portion of my spine. It wasn't like joint or muscle pain. I felt as if the thing that kept me from moving deeper was particulate matter, separate from myself. An entity I should expel. The more I moved into it, the more it became a ripping fire. "Go deeper," some part of me always seemed to say.

◆

Early on in Basquiat's career, a young, Black aspiring artist and model named Michael Stewart was caught drawing the words *Pir Nema* on the subway. The NYPD allegedly used his face to break the window of a patrol car. He was bludgeoned and strangled into a coma and later died. Basquiat's on again off again girlfriend, Suzanne Mallouk, was close with Stewart and covertly photographed every wound on his body in the hospital. She helped his family bring his case to court. When Basquiat found out what happened to someone so like himself, a beautiful Black artist who scribbled on the city's

surfaces, he spent the night drawing black skulls. He made a painting called *Defacement.*

I googled *defacement* in order to see the painting and came upon a similarly titled book by Michael Taussig. The publisher's copy explains, "*Defacement* asks what happens when something precious is despoiled. It begins with the notion that such activity is attractive in its very repulsion, and that it creates something sacred even in the most secular of societies and circumstances. In specifying the human face as the ideal type for thinking through such violation, this book raises the issue of secrecy as the depth that seems to surface with the tearing of surface."

We live in a society wherein white supremacy, and individuals preoccupied by blood lust for the Black body, use law enforcement as a tool. What is it that these men and women, masked, robed, or uniformed, seek to find when they smash the faces of our brothers and our fathers? What pleasure unfurls itself when they go repeatedly—systematically—for our necks? It is as if what is broken there holds secret symbolism. A glowing circle at the cervical spine that, when shattered, bings points for the other side.

At dinner a few weeks ago, my father told the story of a young man in Detroit he knew growing up. A group of famously rough cops told him to stick his face through the open patrol car window. "Please, Dad," I said. But he wanted me to hear it. That particular young man did not die. But you know what comes next: They rolled up the window. They began to drive away.

•

At a certain point, the way I felt when I curved my head forward and stretched my cervical spine became a bit of an addiction. I tried to keep myself from dipping into it too much. But I noticed that if I

had been stressed out or if I consumed weed or alcohol the day be-
fore, the stretch seemed to push that lingering stiffness out into my
blood, heat moving into my stomach before dissipating. I was left
light-headed. I would ask physical therapists and yoga teachers what
it was. Nobody seemed to know. Some encouraged restraint. Others
called it the body's wisdom. Eventually, I weaned myself off because
one day, I spun my torso quickly and heard a sound at the base of my
neck. A whooshing. As if I'd opened up a window.

◆

Basquiat's antagonism toward white audiences became part of what
attracted them to his art. His friend Lee Quiñones notes, "Jean-
Michel's work is very anti–art world, you know. It's almost like a
curse. And people still love that. They love being cursed at." But the
curse seems wrapped up with a gift, somehow. Like the monk who
shouts "shit stick" to awaken a student.

When he was still a teenager, Basquiat coinvented a religion called
SAMO with a friend and wrote about it in the school newspaper.
He saw himself as its leader or prophet. This morphed into the first
act that placed him on the map as an artist. He and Al Diaz painted
SAMO on walls and buildings: "SAMO as an end to playing art,"
"SAMO as an expression of spiritual love."

In *Widow Basquiat*, a biographical novel about his relationship
with Suzanne Mallouk, the painter is obsessed with silent films.
He is especially partial to D. W. Griffith's *Broken Blossoms*. He
memorizes a line that says, "The yellow man holds a giant dream
to take the glorious message of peace to the barbarous Anglo-
Saxons." He would repeat this over and over again. Robert Farris
Thompson asserts, "Basquiat's essays in anatomy, in their jazz-riff
manner of exposition, are style and content in service to healing
on a heroic scale."

If you watch the film *Downtown 81*, you can see the artist walking through the city chanting what was labeled in his notebooks as a prayer: "the earth was formless void / Darkness face of the deep / spirit moved across the water and there / was light / 'It was good.'"

●

After Freddie Gray was arrested for possession of a knife, he was put in a tactical hold, chained to the back of a police wagon, and given a "rough ride." His spine was severed 80 percent at the neck. I tried to watch the video in which he tries to walk after his injury. But the brutality of that killing, the way they chose to break him, still causes my body to squirm, sends my hands to my face where I try to press the image out of my head with the palm of my hand.

When I heard about Gray's death, I thought about the way I stretch my neck. I thought of every lynching. Every chokehold. Each act of violence toward this part of the body that connects us to the brain. Out of curiosity, I bent my neck, let the fire travel along the axis of my spine. I wondered exactly what it was that was being released. If it was even mine.

The Western world likes to separate the mind from the body. It likes to say, too, that some people, some races, are more body than thought. This makes it easier to degrade and oppress. Because, after all, who's there? But the collective wisdom of oppressed bodies, the memory of what has been done to the dead, percolates through us, upward into our ideas, our beliefs, and our dreams. We know.

●

People like to tell the story of Basquiat's death. His addiction has been confused with his talent, as if drug use explains that torrential flow of exquisitely rendered canvases. Only after reading his biography did I

learn how badly Basquiat wanted to be healthy. In his notebooks he wrote over and over again, "Not in praise of poison."

Before he died, Basquiat met a painter from the Côte d'Ivoire named Outarra. They went to a Cy Twombly exhibition together in Paris and walked through the Marais, deep in conversation, eating pastries. Basquiat was starting to think about writing more, and began to make a plan for getting clean. Outarra planned a ritual for Basquiat in his village in Côte d'Ivoire to cure him of addiction on August 7. Basquiat died of an overdose on August 12. They did the ceremony anyway. A ritual for the dead.

Many see Basquiat's paintings and think only of his sad story, his illness. Not ours. And it's been a thing, lately, for white artists to render, simply, the limp Black body, or to utter the contents of an autopsy report. But Basquiat whispered "alchemy alchemy alchemy alchemy alchemy" into the fractured diagrams of the body with what feels like sacred intention, dreaming these anatomical elements back to life. He drew disembodied skulls next to torsos and surrounded them with music, good tidings, rhythm, and crowns as if, upon his command, these disparate parts would dance back together again. What is the name of the Adrienne Rich essay? "When We Dead Awaken."

How to Prepare to See the Royall Family Portrait

1. Discuss Wendy S. Walters's essay "Lonely in America," about the slave trade in New England, with a group of undergraduate English majors. Watch one of their faces transform into a wide-eyed fire stare.

2. Talk to a student after class next to a dumpster about how she didn't realize that it was an option to *grieve* for Black pain after eighteen years of life in white skin. Smile at the tone of incredulity that mounts and mounts in her voice. We've got a live one.

3. Cry at a crêperie with your colleague Jillian, the only other Black person for miles, while trying to describe the end of the Eula Biss essay "All Apologies," where Biss says, "I apologize for slavery." Design a road trip together for students that involves slave memorials and Black conceptual art.

4. In Portsmouth, New Hampshire, reread Walters's essay in a coffee shop at the same time as Khánh San is. Keep looking up and saying quotes in the exact same breath by accident. For example, say in unison: "Hearing that Africans are buried beneath a public street in a small coastal New England town gave me a new context to reconsider what is obvious and how one might learn to live with it."

That essay comes from a book that feels like a series of airplane rides. The reader arrives at a real city, but in between each fixed space, you are sleeping on the plane; periodically, you wake long enough to make eye contact with the person sitting beside you. "We tried not to think of a single one of us as unfinished," Walters writes in one essay, an ephemeral journey. "We studied other fictions to understand what had made us so angry. We looked through books for evidence of our arrival. All the stories about when we fell in love or died. So many endings."

5. As you approach Valerie Cunningham, your Sankofa tour guide, coauthor of the book *Black Portsmouth* and founder of the Portsmouth Black Heritage Trail, ask your student Avery to sing the Amy Winehouse cover "Valerie." Valerie is wearing a V-neck T-shirt and soft clogs, and she is either sweating or crying and is very much a queen.

6. During the tour, jot down the following in your notebook: "Fifteen-year-old girl in exchange for some lumber." "Where might she go?" "I didn't want to spend time researching white people's houses." "So here's the long wharf where Negro boys and girls could be sold." "Nigger shoes, flat, cheap, leather shoes." "Shoe factories have been renovated to be artists' studios." "Ona Judge escaped the presidential White House, came to Portsmouth." "Ona had three kids who died before her." "Valerie, you have to get to Chestnut Street they found something." "And then my heart jumped." "A manhole six feet down struck coffin board." "Bones were not complete bodies." "You don't want things rattling around in there." "Caesar, Newport, Dinah, Nero, Venus, Flora." "Someone's in the kitchen with Dinah?" "Probably." "Like pets."

7. Enter the Seacoast African American Cultural Center. The white woman at the door will tell you, "If you can guess what the big lobster upstairs is, you can have it." Walk upstairs to see Khánh San holding a giant pink stick: "Guys, I think it's a coffin." You are standing in front

of a pink lobster coffin that your students have disassembled. It is next to the diorama of the Sankofa slave memorial. "Can this be right?" everyone keeps asking. "CAN THIS BE RIGHT?" When Khánh San tells the woman downstairs that you've all guessed it, it's a coffin, the woman explains that it was made by a visiting Ghanaian artist, and, yes, you can take it home if you want. Nothing makes sense.

8. Decide that you will find a place to stay "based on the kindness of strangers." Begin driving in the direction of the nearest exhibition of Black art. This is just under two hundred miles away.

9. Read a Hilton Als article about Kara Walker to your students as a bedtime story. Sleep in Vermont. Wake to fog rolling in over a lake.

10. Go to Williams College for the exhibit *African Art against the State* and have the students peek at a Kara Walker print in the Object Lab.

11. See three *Vogue*-like photographs by Fabrice Monteiro as part of *The Prophecy* series, in which thin Black women emerge in triangular shapes over dead birds and multicolored trash from an ocean or a burning desert or a smoldering landscape with black plastic bags hugging their faces, staggering, offering green foliage upward.

12. Look at masks by Romuald Hazoumè made with discarded, burned, melted, and ripped-up jerricans, pocked by ash, the "mouth" of one bottle opening off to the side.

13. Drive to Amherst. Walk around Emily Dickinson's property even though the museum is closed. Look in the windows. Say over and over again, "Wild Nights—WILD NIGHTS."

14. Walk from Dickinson's house to West Cemetery, where she is buried. Walk straight past Emily Dickinson's grave with Jillian in search of the graves of African American Civil War veterans.

15. Laugh about the possibility that it is that overgrown hill over there.

16. Ask a white woman wearing a shirt that reads EDUCATION where the Black graves are. She will say, "Where you'd expect them to be."

17. Walk to where she pointed and realize there are graves even beyond what you thought was overgrown. Avery is singing, "Oh, sisters, let's go down," softly, under her breath.

18. Wade through weeds as thick as bamboo, taller than you are.

19. Stand with your coterie, feeling, as Jillian says, "gobsmacked." Cam wants to come back tomorrow with a machete. Avery points out that a gravestone says, "Amidst life, we are in death. Stop, reader, and learn to die." A small red spider crawls on your notebook. Behind a wall in the apartment complex behind you, a young man asks, in an exaggerated southern accent, if someone is smoking reefer in the graveyard.

20. See a grave for an Erasmus, surrounded by tiny purple flowers.

21. See a grave for a six-year-old who died in 1809.

22. Watch a man take a photograph of a woman eating pizza in front of cat graffiti in an alley.

23. Sleep in somebody's backyard. Their neighbor walks a dog around the house without saying hello, saying "woahwoahwoah" as the dog barks and lunges. There are blue-lit dolls in the neighbor's window.

24. Drive to New Bedford. As you get unlost, Liz talks about the emotional politics of working with cadavers. Visit the visitors' center across from the whaling museum, where a man whose body

language contains just a hint of Stuart from *MADtv* explains the relationship between whaling and slavery. He concludes his spiel by saying, "What can I say? America is a complex place." The memory of this utterance will send Liz into giggle fits for weeks on end.

25. Stand in front of the first house Frederick Douglass and his wife stayed in upon realizing freedom. Watch a Black man across the street sketch for a while. Approach him and see that he is coloring. "What are you listening to?" Avery asks. "Wu-Tang," he says.

26. Drive to Cambridge. In the car, Khánh San shouts the entirety of Eunsong Kim's article about how Harvard told Carrie Mae Weems that the slave daguerreotypes she used for the series *From Here I Saw What Happened and I Cried* were "owned" by the university because they were collected by the father of eugenics and Harvard professor Louis Agassiz.

27. Buy tickets for the Fogg Museum a half hour before closing.

28. Spend twenty minutes standing in front of the Weems portraits, noticing how the docent with remarkably big muscles to your right seems like he's getting closer and closer to you. He says, "You can't use a pen," so you ask him for his tiny pencil.

29. Keep thinking that the Kiki Smith sculpture *Pee Body* is an actual person.

30. Listen as a female docent tries to tell you something about the royal family. You're still in docent-as-police-state mode, so you don't listen very well.

31. After a few seconds pass, say to this docent, "Wait a second—what do you mean?" She points upstairs and says something about "Harvard" and "admits" and "slavery." You all run up the stairs.

32. One red-tie-sporting docent after another says, "Five minutes left," like a Christo installation. You wander through the rooms unsure of how you'll know when you've found it. When someone asks if you need help, you all explain chaotically and simultaneously what you think you're looking for. Somebody points.

33. You run.

34. Stand in front of a portrait of the Royall family, who got their money through the slave trade and donated their land to Harvard. Read the placard that says, in essence, "We got what we have because we stole and we raped and we murdered."

35. Exchange high fives with the person standing nearest to you. Don't be afraid to share your joy with the nearest docent; she is just as thrilled as you are.

Caldera

In the fall of 2016 I went to teach at a writing residency in Oregon. During my first bout of free time I decided to take a hike along the edge of an exploded volcano, which cradled an absurdly blue lake. I jogged for a while. I turned around in circles like Mary Tyler Moore and thought about how lucky I am to have come to the point in my life where my *job* is to be in the woods with rivers and lakes and to think up arty ways to play with writing and dirt.

The path turned off to the left, away from the lake, and I remembered what the groundskeeper had said about staying off of private property. A shot cracked the air open and I turned around and ran. Negotiating the possibility of a panic attack, I texted my colleagues— "Someone I am hiking and there are gunshots I am scared on trail aroun [*sic*] the lake"—but there was no signal. I could feel that I was ridiculous and not ridiculous because all signs told us we were deep in Trump territory and there had been videos online of people in militias "preparing for the election" in a location that looked, to this urban-born child, a lot like this one. My mind flashed to the character in the narrative of Frederick Douglass's life who runs into a creek to escape a lashing; somebody takes out a musket and "in an instant poor Demby was no more."

I surrendered my hands and called out, "Help! Hello?" and scooted down the hill on my butt thinking maybe I could cross the lake to get back. I peeked over the crest of the hill and there was another shot. Eventually, I decided that it was time to move again. I began to pick my way back along the path I'd taken. I felt foolish for having thought that I was allowed to be there and to feel safe. I thought about Camille Dungy's poetry anthology, *Black Nature*, and as I clasped my own hands together in a kind of prayer, I was also holding hands with those poets who spoke of hunting and hiking and Blackness.

A hawk flew overhead and I felt very sure in that moment that he was keeping an eye out for me, though usually birds of prey make me worry because my hair has been plucked at from above more than once for what I assume are nesting purposes. The hunter whose gun I'd likely heard appeared with his family in the distance. I wanted to walk in another direction from theirs and I couldn't. We intersected and I tried to make conversation about the dogs but the younger two generations of the group, men in their thirties and boys under ten, would not make eye contact with me. All but the dogs were white.

The eldest man was kind. "You're perfect," he said, as I explained that I hoped I hadn't made a wrong turn and wandered onto his property. His words sounded strange to me in this context, like I was his daughter or a roasted turkey: "Perfect." When I got back to my very Norwegian cabin I put on some music and wrote everything down and I noticed that Beyoncé was singing "Daddy Lessons," which she had just sung at the Country Music Association Awards and which had made a lot of people angry. As I listened I realized that I had no idea what her daddy meant when he said "shoot."

At the beginning of my hike, before the gunshots, I had been thinking about how to create a writing prompt based on the Eileen Myles essay "What I Saw." In it, Myles describes the time she watched

Pope.L perform *A Negro Sleeps beneath the Susquehanna* at an art-
ist's residency. He keeps uttering the word *crab*. He keeps saying,
"Wish *I* could dream." He straps a mirror to his back with jagged
lines of tape stuck across it, wades down a river, and disappears.
Myles writes, "The mirror on William's back sometimes felt like he
was carrying the river, that he was the river himself that he *was* it.
He seemed to vanish into everything there was, walking further and
further away from us. The voice was gone but you still felt it. And
the breathing too."

I wondered if residencies are a bit of a thing for Black people more
generally. All of the Black people whom I told about what happened
chuckled and muttered under their breath, "Oregon."

Months earlier, I had been driving to my job as an English compo-
sition instructor at a community college when I saw that the school
was on lockdown. A police officer was hiding behind a giant sign with
the school's name on it, holding an AK-47. As I contemplated whether
or not to turn into the parking lot, I began counting pairs of red and
blue flashing lights. I saw an image of myself crouching into some-
thing, falling inward on myself in an unyielding place, in a corner or
a vortex or a classroom. The radio was not on because I had turned
it off because they had been reporting on the student who'd killed
his English teacher and fellow students at a community college in
Oregon the week before. I kept driving.

One night, some days later, a friend had a few of us sit near the train
tracks at the center of town. She handed each of us a book by Clarice
Lispector and asked us to open to a random page. My passage, the
one I read out loud, was about eating a cockroach. The point of
the exercise was to use bibliomancy to "read our lives," like tarot
cards or a horoscope. So, in this symbolic scene, was I the one eat-
ing the cockroach? Or was I the one being eaten? A little bit of both?
When my dog hears me yelp in a certain way she will rush into the

bathroom. I'll point to the cockroach and say, "Kill it," and she will find it and tear it apart with her paws.

Another time, in a forest, I sat with a group of students on the day that forty-nine people were shot and killed at the Pulse nightclub in Orlando. We were in a technology-free environment, so the students had no way of knowing what was going on in the world. I wasn't sure whether or not to tell them, but my boss began to play Sinéad O'Connor's "Nothing Compares 2 U" on the piano in the dining hall downstairs and his voice kept hitting those high notes and I told my students that we had to leave the building. I ran out like someone about to puke, and by the time we got outside I was sobbing. I could feel myself swerve from grief into melodrama as I told them about the shooting. And what it felt like was crowd-surfing. Like they had hoisted me on their shoulders and carried me away.

The election happened while I was at the residency in Oregon, and as the results were coming in, while our phones were off, the poet CAConrad was telling us a story about listening to a mash-up of the sounds made by extinct animals. They spoke of swallowing the crystal worn by their murdered boyfriend and shitting it out and writing the grief that the rock gave them. Those of us in the front few rows could tell what was happening to the country because CA's eyes kept widening, trying to parse the commotion at the back of the room. Chairs moved. Screens reddened. Somebody wailed. I threw up bile in the sink the next morning. When I finally met with my students again for workshop we moaned and stomped our feet in the absurdly blue lake. "What zone are you in?" my father asked me on Skype.

Brigitte was wearing a buffalo around her neck, so I told her about the video from Standing Rock in which a man is talking and then all of a sudden he says, "Look, look at the buffalo," and the video shows a herd of them appearing out of nowhere, and my voice cracked when I reenacted it. She went off to watch the video on her phone,

cupping it between her hands like water. Later, we decided that she had to scream something she had written while we listened from outside. Later, I walked in and she and Shannon were harmonizing about rivers. Later, I found out that it was my little cousin who recorded a classroom full of children as they shouted "Build a wall" at their schoolmates in an elementary-school cafeteria. Later, I found out that at Standing Rock, they built a wall around the buffalo.

On the plane home from Oregon, a man turned his head in the seat in front of me and he reminded me of a boy I went to elementary school with who would curl into himself like a bug if he heard the word *Hitler*. And I participated in the taunting. And his father was small and wore black and used crutches to walk. And in European history class during high school I would cross out Hitler's name every time I wrote it, as if in penance. But there was nothing I could do to erase what I had done. And there was nothing I could do about the fact that the only way to get home on the day I was scared of getting shot was to cross paths with the hunter and his family.

That Black Abundance

In 2006, while I was sitting outside a gay coffee shop in Tucson, a man explained very calmly that America would soon begin to see more and more shootings like Columbine. He predicted something about the presidency I probably didn't even know how to hear then. It was like he was reading tea leaves. His worldview was a little more Illuminati than bears repeating (Condoleezza Rice is a lizard, etc.) but I think about what he said all the time. He seemed to exist on another plane, looking at our national trajectory from a remove. He was HIV positive, white, self-healing, an avid reader.

In the film *Six Degrees of Separation*, written by John Guare, Will Smith plays a character who calls himself Paul, who shows up at the door of a fancy New York apartment with a knife wound. He tells the wealthy white couple who live there that he is a friend of their children, from Harvard. He lets slip that his father is Sidney Poitier, initiating a seduction so skillfully attuned to the intricacies of white fear and desire that it could teach an alien how to identify a white liberal from outer space. At a peak moment, Paul describes a thesis he says he's writing about *The Catcher in the Rye*. He notes how many famous killers cite the book as an influence, and recalls: "On page twenty-two my hair stood up. Remember Holden Caulfield—the definitive

sensitive youth—wearing his hunter's cap?" Paul recalls Caulfield's realization that his hat is "a people-shooting hat. I shoot people in this hat." He says, "This book is preparing people for moments in their life I never could have dreamed of." Paul's character is based on an actual person named David Hampton who would eventually die of AIDS.

Paul mystifies his hosts as he continues to talk about the way Caulfield succumbs to paralysis, unable to face the people he has come to despise, or himself: "To face ourselves, that's the hard thing. The imagination—that's God's gift to make the act of self-examination bearable."

I want to talk about James Baldwin's unerring insistence on calling attention to the way that racism is a psychological problem, symptomatic of the fact that white people refuse to face their own culpability or pain, which is to say, from self-actualizing. I want to talk about the way James Baldwin, John Guare, Kiese Laymon, and my Tucson friend so gracefully point out the obvious: that our numbness, our inability to face ourselves, is starting to have violent consequences. Catastrophic, war-like blasts of self-annihilation. These writers all called it. Call it. Keep calling it. But in *Heavy*, Laymon's is a world where white people barely factor in to things, except that they do: "I didn't hate white folk. I didn't fear white folk. I wasn't easily impressed or even annoyed by white folk." His analysis of whiteness is practically incidental. His focus is on Black abundance.

From the sidelines, white folk are frequently caught enacting intentional acts of everyday cruelty. When a teacher asks Laymon and his friend LaThon to tell their friend Jabari to bathe because he smells "gross," she adds, "You guys can understand how that is not good for any of you, right?" Laymon spends the rest of the section illuminating their dismay at their teacher's request, especially given the cause of Jabari's smell: "Ever since his mother died, there was just a

different scent as soon as you walked in Jabari's house." The word *gross* reverberates for everyone, starts to take them down. And what's gorgeous about these small humans, eighth graders at the time, is how they enact such visionary kindness, such heroic compassion, that their teacher's ugliness seems less and less small, taking on an almost mythic dimension.

These boys ignore their teacher's request and instead work to make their friend feel seen, held, loved, not alone. Nobody tells Jabari he's gross. Instead, Kiese joins forces with him: "On the way home from Jabari's house that day, I grabbed a T-shirt from his dirty clothes. . . . I came to school the rest of that year with my breasts, my love handles, and my stomach compressed in a T-shirt that smelled so much like Jabari's house. When white folk at St. Richard looked at me like I was gross, I smiled, shook my head, sucked my teeth, intentionally misused and mispronounced some vocabulary words."

Language play is a key tool for Laymon in dismantling the lies and cruelties constantly pitted against the people he loves, against the notion of Black abundance: "While that abundance dictated the shape and movement of bodies, the taste and texture of our food, it was most apparent in the way we dissembled and assembled words, word sounds, and sentences."

Kiese and LaThon have a kind of call and response between them. Kiese will say: "It's still that Black abundance?" And LaThon will say: "Yup. And they still don't even know." These boys live in a space of total clarity about the performance and stakes of white gracelessness: "for all that bouncy talk of ignorance and how they didn't really know white folk, especially grown white folk, knew exactly what they were doing. And if they didn't they should have."

When I first read Laymon's novel, *Long Division*, I was overwhelmed by the dialogue, which showed an attunement to the genius of children

and especially Black children, a genius that adults somehow train themselves not to notice. And it is this contortion, this willful act of unhearing, of feigned innocence, that most defines whiteness in Laymon's books. White folk come across like a freaky painting. What Paul in *Six Degrees* describes as a "funhouse mirror." What Laymon foregrounds is a galaxy of astonishing wit, ordinary to those who wield it, invisible to everyone else.

Laymon marvels at LaThon's engineering prowess: "I once watched him tear open a black-and-white tv and make it into a bootleg version of a Frogger and a miniature box fan for his girlfriend. One Friday in 7th grade, I saw him make the freshest paper airplane in the history of paper airplanes in Jackson. For five minutes and forty-six seconds, that plane soared, flipped, dipped, while LaThon and I ran underneath it for three blocks down Beaverbrook Drive."

What world have we signed off on that doesn't celebrate this fucking poetry of being? Laymon engages, through language, in an act of engineering, a refashioning of the TV set. And when I say "he's refashioning a TV set" I don't mean that he's refashioning a lens. This is neuroscience. I don't know who you hang out with these days, but in 2017, a white lady unselfconsciously used the word *ebonics* to describe how Black people talk. Everyone is still wired wrong. Laymon thrums each thread of what we've learned to call invisible until the whole world starts to vibrate.

After his class watches a scene of sexualized racial violence in *Roots*, he recalls "the St. Richard white boys moved with the same eager stiffness they always moved with during break. A lot of the white girls at St. Richard and all of us Holy Family kids moved like we'd had a burning secret poured into our ears." Laymon is interested in the fact that children learn very quickly that their bodies can be invaded at any moment, and adults don't say a thing about it. His book tells his own story of surviving sexual violence, but it also tells the

story of a country that sustains itself on the fact that there are and will always be perpetrators and survivors; our citizenship.

In *Six Degrees of Separation*, Will Smith the actor pretends to kiss Anthony Michael Hall the actor, even though the audience is meant to believe that Will Smith's character has actually kissed Anthony Michael Hall's character. But the approximation of this gesture is also, it seems, calculated to signal to the viewer that no actors' mouths were compromised in the filming of this sequence: an excessive "smooch" sound adds an element of kitsch, a wink, a homophobic wince.

When I saw the kiss while rewatching the film recently it unleashed a spray of shame that I'd experienced the first time I saw it. My own queerness has incorporated these kinds of moments of disgust into itself. In this way, I move like most Americans, with "eager stiffness," emotionally unbalanced, compromised—just like I compensate for the weakness in my hips, my knee, and my toes, by overworking the muscles in my back.

The thing that echoes for me most about the film, especially in the wake of *Heavy*, is that my father, like many men in his generation, is a version of Paul. Paul who says "bottle" like *bott-hul*, not *boddle*. Who says in response to a double-sided Kandinsky: "Wuunderful!" Like Paul, my father used his creativity to craft a Black persona suitable enough to be invited into fancy rich white people's houses. He studied at Harvard, traveled around Europe, learned German, which he mostly uses to surprise people who speak it in elevators in front of him assuming he can't understand. And as he gets older, as I see him wax nostalgic about his career, his hopes, his betrayals, I see all the ways that he's been institutionally sidelined and excluded and dismissed for reasons mostly related to race. I wonder what other life his abundant mind might have invented if he'd known at the outset what white men would take from him.

Laymon gives no false advertisement for the path he took—facing away from whiteness has made him just as broken, sick, addicted, abandoned, dangerous, lost, and burdened as any other American. But his effort to model a life in service of Black abundance is at least optimistic about what we might all unleash if we were kinder, if we looked at all the lies we tell ourselves.

At the end of *Six Degrees of Separation*, Paul is on the phone with Ouisa, the white wife of this art dealer couple, long after his charade has been revealed. Over the course of their conversation, Ouisa begins to see her own life with new clarity. What kind of a thief is her husband? What kind of a thief is she? She walks away. Starts over. Despite the fact that this astonishing film is about the evils of whiteness and capitalism, Paul still amounts to nothing more than a tool for someone else's awakening. One character says, "He opened up a whole new world to us. That's all anybody wants, isn't it? A new world." He languishes, maybe even dies in prison while Ouisa gets to fly. It is clear to me that my father has become his own biggest obstacle, never quite passing through a kind of threshold himself, into a new world—a place where, as they say, he might get his flowers. The fear that someone might steal what he's accomplished makes him skittish. When we're on the brink of finalizing an exhibition or the acquisition of one of his prints, he'll often swerve, preferring to hold his life's work close to his chest rather than let some stranger walk off with it. What does it mean, after all, to succeed in a system that hates you?

Laymon has said that he worries that white people like his work too much. It is hard to write about suffering and to know that people enjoy it. But in reading his work with my students, who represent a genuine spectrum of identities, I can't agree that what he's enacted in his readers is only fetish, or parasite, or escape. I asked them to come up with a series of writing prompts in response to *Heavy*, and we sat together in our classroom in a bell tower and we wrote a lie.

We wrote a story we weren't sure we were ready to share. Thought about a time someone saw us as "good" though maybe we knew we weren't. We wrote about a relationship in our lives that is or was heavy. We started from the place that broke our hearts. We made our hearts come back together.

A journalist once called me for a quote about Kiese Laymon. I told her that I didn't want to sound ridiculous, or religious, and then I mumbled words like *bodhisattva* and *prophet*. I laughed, embarrassed, expecting her to sound surprised. But she said that I must have been the fourth or fifth person to say so.

The Ornithologist's Husband
Dreams of Annihilation

If I try to conjure in my imagination what a biostation looks like, I see a hexagonal white building, not unlike a yurt, but much larger, industrial, with hard surfaces and edges. This may be because I lived for many years in Arizona, where the strange beauty of Biosphere 2 looms like a museum or a spaceship in a desert city called Oracle. Or I think of the glass-enclosed terrarium on the show *The OA*, where several survivors of near-death experiences are held captive by a scientist. A river moves underneath their transparent cages. On *The OA*, we are meant to wonder what it would mean if one of these captured subjects were an angel, but the suggestion is slight, more of a metaphor than a plot device, a way of asking what the word *angel* might mean outside a religious context. I've long conflated angels with dreams because of the film *Wings of Desire*, where angels hover above the living. The hovering creatures can hear what people are thinking. These angels become a way of outwardly describing the subconscious: all those individual streams of thought join together and become a river.

I recently spent ten days at a biostation where I taught a writing workshop. The biostation is located in a rural setting near a lake. The area was logged aggressively long before the station was established,

so the forests are relatively new. Biologists and ethnobotanists and climate scientists study flora, fauna, water—biota. It looked nothing like the biostation of my imagination. Really it was a road lined with uniform cabins, along a lake, punctuated on either side by pale-green forest. Cabins filled with strings of light and wood-burning stoves and mosquito netting. There was a cafeteria. A library. An awkward-looking mallard nest high up in a tree above the volleyball court. A room filled with bird specimens, which I discovered when the body of a lifeless owl caught my eye one day through a window while I was lost. Some days, there are potlucks, and people who care about each other very much make small speeches over a candle or some bread.

The students I have come here to write with have recently learned about the Burt Lake Band, indigenous inhabitants of this land forced to leave when it was set on fire. They tell me about an old woman who walked away from the fire, only to collapse when she encountered help. They teach me how to speak some phrases in Anishinaabemowin. How you might identify yourself in a greeting by describing the body of water closest to where you're from.

One night, I attend a talk on climate change. There is standing room only, so we sit on the floor in the hallway outside the auditorium. The director giving the presentation says things like "The world is getting warmer." He is starting off slow. Then, things get a bit technical. He makes CO_2, O_2, methane, nitrous oxide, and nitrogen molecules wiggle in his PowerPoint slide. Then he says, "That's heat," and people laugh. The icons for molecules look, to me, like prescription drugs in the sky, or Band-Aids. He uses his own biography to contextualize the rise of CO_2 over time: it has been increasing since he was in second grade. He tells the story of a man who went out to a mountain, opened a flask, and brought the air home with him. He quotes Henry Pollack: "Ice has no point of view. It does not vote. It just melts." I jot down phrases like "We have twelve years to change it around." "Wet gets wet, dry gets drier." And "We're looking at

chaotic winters." Every difficult fact is dispensed in an even tone. He will say, periodically, "so," as if giving us some space to breathe.

What gets me is when he tells this one joke. The curve of CO_2 on a graph is called the "hockey stick." He and his colleagues call the curve of CO_2 and nitrous oxide "the hockey team." People laugh. It's a dad joke. But the instinct to continually bring the audience comfort—almost offhandedly—strikes me as generous, especially considering how powerful it might make a person feel to let despair just flatten the room. Before that, I had been focusing my attention on nervous tics. People shaking their legs, getting up to pee, fiddling with phones. We are all, without any outward sign of panic, absorbing facts of our unbecoming that the nervous system has no mechanism to deal with. When the climate scientist makes this small joke, I crane to see his face.

In his office, later, he tells me that he recently had a dream about flying in a plane across the Atlantic. All of a sudden, the nose of the plane began to rise, going straight up into a dark cloud. It curved, made a back loop, "like a loop-de-loop on these scary carnival rides." The pilot announced that he had lost control. It was time to make peace with the end. The climate scientist referenced this particular kind of dream as a recurring trope, "making peace with the end dreams." In a different style of dream, he solves problems, like the one about tree roots. What we end up talking about, mostly, is his concern about the social dimension of our coming catastrophes. How will we behave toward one another as things begin to change? He reminds me, I realize, of the kindest character in a movie about a woman who falls in love with Death.

I begin to talk with the other scientists about their dreams.

The resident biologist lives year-round at the biostation with his wife, who studies birds. He wakes up every day and bikes to various weather stations to take down new data, noticing the way the plants have changed as the season warms or cools. But first, he goes to the yoga

room in his house and does pranayama, or breath work. This practice manifests in his way of speaking, which is itself like a guided meditation, slowing even my breath down. "Lately my dreams have been pleasant, I would say. Mostly with friends. Although, I did have a dream recently involving a battle with a giant metal dragon thing, but I think this was inspired by a couple of things: the movie *Annihilation*. Have you seen that?" He describes the organism at the center of the film, "the shimmer," which is both an entity and an area. He recalls a beer label that may have provided some of that dream imagery, too: "The bottle had this metal cobra robot thing with guns." He doesn't remember the dream well, but, "I remember waking up and feeling not afraid, feeling pretty confident, which surprised me."

The ethnobotanist dreams of walking. "Sometimes I dream about here, walking through these woods, or sometimes I dream about Guam, walking through those jungles." Guam is where he did his fieldwork. "Just being in the plants, being in the forest, or being in the desert . . . almost like a vector, perceiving everything around me."

The outreach coordinator records her dreams in a journal. She reads some aloud. In one, she has been forced to recite an old Latvian proverb in order to avoid being turned in to the police. What wins her freedom is an actual saying: "Those without shame never go hungry." She has "Kubla Kahn" memorized, a poem that came to Samuel Taylor Coleridge in a dream. I ask her to recite it, and my eyes flit to the window as she speaks. The poem feels like a wild iteration of where we are: "And 'mid these dancing rocks at once and ever / It flung up momently the sacred river. / Five miles meandering with mazing motion / Through wood and dale the sacred river ran, / Then reached the caverns measureless to man."

A general ecologist works in lakes. She doesn't recall her dreams of late, but remembers that, as a child in Minnesota, she had a recurring nightmare in which her little brother drowned.

The associate director dreams of flying, which she used to do on helicopters during her fieldwork in Alaska. "It's very much like the dream of flying, because . . . you're going slowly, so you can turn, you can swoop." Once, in the Arctic Wildlife Refuge, they "flew out to a stream, and the clouds came down." They could see that rough weather was coming. She and a colleague had to get out to lighten the helicopter and wait for several hours to be retrieved. "We had a radio, and before I could even see or hear the helicopter, for some reason, I heard my radio came on and he said, 'Oh Kaaaaaarrrrrie.'" She manages to capture the pilot's deadpan, even evoking the crackle of the radio, in her mimicking of just two words. She laughs with infectious delight. "I'll never forget that."

A geographic information systems professor dreams, sometimes, about being caught up in a flood. He studies cities like the one where he grew up, fashioning models that demonstrate what would happen if that place were to be inundated by sudden water. He remembers, as a child in Côte d'Ivoire, that children were carried away by a current that swept down streets and between buildings with little warning: "If you touch it, you are gone." In his work, he sometimes shows a video of a young boy caught up "in the middle of a very wide channel." He doesn't know if the boy lived or died. His dreams, like his models, afford him a kind of access to the perspective of that boy, and of the children he saw disappear.

When I tell her that I've been asking scientists about their dreams, my wife sends me a photograph of a page in a book she's reading, called *The Art of Mystery* by Maud Casey. This particular page contains a passage about Werner Herzog's film *The Cave of Forgotten Dreams*, wherein the filmmaker joins a group of scientists in the Chauvet Cave in the South of France. Very few people have been allowed permission to enter this place, but this film crew captures some of the earliest drawings created by humans. Herzog encourages one of the scientists to talk about his dream of waking up inside

the cave alongside the bones of saber-toothed tigers. Casey writes, quoting Herzog: "'What constitutes humanness?' he asks a group of archaeologists."

I go down a rabbit hole of Herzog's films, ending at *La soufrière*, which was made in 1977. The film is about a volcano in Guadeloupe that is about to erupt. The filmmaker and his team of brazen companions travel to the island just as nearly everyone else has evacuated. They drive toward the caldera, encountering toxic haze. One of them leaves their glasses on the volcano. They are eager, for some reason, to enter into the precise heart of the catastrophe. On a helicopter ride, Herzog explains, "We got the impression that these were the last hours of this town, and the last pictures ever taken of it." The sea is full of dead snakes that had crawled out of the volcano. An instrumental version of "All by Myself" is playing as the filmmakers take sweeping shots of the evacuated island.

They track down three men who have refused to leave. One stands in the middle of an empty intersection, his arms akimbo, contemplating departure the way you might consider a trip to the grocery store. Another man is houseless, sleeping in a secluded area, cuddled close to a black-and-white cat. When they ask if he is afraid, he says, "Not one bit." He explains, "Death waits forever, it is eternal." He is wearing a dress shirt. He laces his shoes, which look like high-top black Converses. His graying hair wafts in the wind and he begins to sing.

As if to thwart the valor of this foolhardy gang of cameramen, the volcano never erupts. Like so many Herzog fans, I move between feeling charmed and feeling vaguely annoyed by the brotastic quality of this particular adventure. But after it ends, I begin to feel a bit of a chill, replaying Herzog's words in my head as I look at the scenes from my own life: "These were the last hours of this town."

Ladies of the Good Dead

My great-aunt Cora Mae can't hear well. She is ninety-eight years old. When the global pandemic reached Michigan, the rehabilitation center where she was staying stopped accepting visitors. There were attempts at FaceTime, but her silence made it clear that for her, we had dwindled into pixelated ghosts. She contracted COVID-19 and has been moved again and again. When my mother calls to check on her every day, she makes sure to explain to hospital staff that my great-aunt is almost deaf, that they have to shout in her left ear if they want to be heard.

Cora Mae has a bawdy sense of humor. Most of the time when she speaks, it's to crack a joke that would make most people blush. She wears leopard print and prefers for her hair to be dyed bright red. I have tried to imagine her in the hospital, attempting to make sense of the suited, masked figures gesticulating at her. She doesn't know about the pandemic. She doesn't know why we've stopped visiting. All she knows is that she has been kidnapped by what must appear to be astronauts.

The film *The Last Black Man in San Francisco* begins with a little Black girl gazing up into the face of a white man who wears a hazmat

suit. A street preacher standing on a small box asks, "Why do they have on these suits and we don't?" He refers to the hazmat men as "George Jetson rejects." It feels wild to watch the film right now, as governors begin to take their states off lockdown knowing that Black and brown residents will continue to die at unprecedented rates, taking a calculated risk that will look, from the vantage point of history, a lot like genocide. The film's street preacher sounds obscenely prophetic. "You can't google what's going on right now," he shouts. "They got plans for us."

●

Under quarantine in Detroit, my father has been sifting through boxes of slides in his sprawling photo archive. Each image unleashes a story for him. Last week, he told me about arriving in Sarajevo while he was covering the Olympics. He stayed with a family of friendly strangers eight years before the war. "I wonder if they survived," he mutters to an empty room.

When my cousin was a police lieutenant, she told us about getting a call for someone who had died. At first glance, they thought the man had been hoarding newspapers or magazines, but then his daughter explained that he was a composer. The papers in those leaning stacks were original compositions.

When we hear on the news that Detroit is struggling, that people are dying, do we imagine composers? Do we imagine a man who sifts through photographs of Bosnia before the war?

In a painting by Kerry James Marshall, *7 am Sunday Morning*, a long, horizontal city street appears mundane on one side, but morphs into hexagons and prisms and diamonds as the eye moves right, as if the block is being seen through multiple panes of differently angled glass. If you peer closely at the building on the left, what look like

wisps of smoke wafting out of a brick building can be discerned as delicately rendered musical notes. They curve underneath a flock of birds that flutter over a beauty school and a liquor store. The almost unbearable majesty of this ordinary city block evokes Detroit for me. Some summer afternoons, a lens between me and the world gets cracked, and the light and the people and history and the sky go wonky and the moment feels achingly eternal.

●

In 2019, the Detroit Institute of Arts mounted an exhibition called *Detroit Collects*, featuring mostly Black collectors of African American art in the city. In one room, giant photographs of collectors in very cool outfits hovered above. Immediately I recognized the wry smile of a woman named Dr. Cledie Collins Taylor.

My parents have been telling me about Dr. Taylor for years. "You're going to love her." "Her house is a museum." "She used to live in Italy." "She loves pasta." When a friend came to town, we thought we would go to the Detroit Institute of Arts, but my father took us to Dr. Taylor's house instead. The sun was spilling across the horizon, raspberry sherbet bleeding into orange, and the temperature was in the low teens. A handful of houses along the street had big paintings integrated into the architecture of a porch or a window. We knocked on a security gate and a woman in her nineties welcomed us inside.

"Every February, someone discovers me," Dr. Taylor joked, nodding at the coincidence of receiving extra attention in Black History Month. I felt a twinge of embarrassment. Here I was encountering one of Detroit's artistic matriarchs for the very first time, and it would be February soon.

Art in this city is on display at the Detroit Institute of Arts, one of the most gorgeous, palatial museums I've ever visited, on par with

the Musée d'Orsay. Spectators can gawk at Diego Court, their faces striped with sunlight, imagining the ghost of Frida Kahlo off to the side of the room. But art also bursts out of the city's residential neighborhoods. You can find paintings by one of the city's biggest rising stars, Tylonn Sawyer, tucked inside a gallery like N'Namdi Center or projected onto a screen at the DIA, but you are even more likely to see it flash like an apparition in your periphery (two children gazing upward, golden orbs radiating behind their heads) as you drive past a nondescript building near the warehouses surrounding Eastern Market.

At Dr. Taylor's house, we sat in the living room and talked for a while. A slight Black woman with short white hair wearing a simple black dress. The impeachment hearings were playing loudly on a television in her bedroom. "A lot of my collection is upstairs. Why don't you go take a look." We crept carefully through a room that seemed to be fitted with exactly as many books as it could tastefully hold, toward a narrow stairway. Upstairs, canvases were stacked like vertical files along the walls. A figurine stood, stark, in a room off to the left. There was a photorealistic painting of a Black woman with short hair, in profile, wearing a pink turtleneck and sitting on a white couch. A black-and-white print of a man with hair like Little Richard's peeked out from behind a stack of frames. In a round canvas, a man with an Afro slouched behind a shiny wooden table, seated in front of geometric panes of blue, including a massive window framing a cloudy blue sky—as if Questlove were relaxing to "Kind of Blue" inside a Diebenkorn. Ordinary scenes of Black life, exquisitely rendered, were scattered across the room, a collection relaxing into itself with a kind of easeful, dusty abundance. We were called back downstairs.

Dr. Taylor walked us through the house and took us on a tour of the basement. African masks, sculptures, shields, and figurines were pinned to pegboard the way other basements showcase drills and

rakes. I placed my hand on the baby bump of a pregnant wooden figure, weeks away from knowing whether or not a recent round of IVF in my own womb might take. "Somewhere along the line, the collecting idea just catches you," Dr. Taylor said, humbly.

"You could tell where the problems were because you'd get a lot of things from that place," she said, of collecting work from Africa. "I realized that people were responding to what they needed; certain things in their family shrines they could part with, just to eat." She told us about a friend, a playwright who convinced a general not to kill her family during the Biafran war. Dr. Taylor tried to hold items and then give them back when wars had ended, once she realized why they'd become so available, but she struggled to get past corrupt middlemen.

She told us story after story about the objects in her home, reaching her arms so that the fabric of her dress stretched like a wing, rendering details of character and plot to bring each item alive: "She got some men who carry lumber to carry her under their wagon," and "He was a smooth talker, very good looking."

Dr. Taylor has been around the world twice. A trip to Iran ended early when the shah fell ill. She has spent entire years on sabbatical living in Italy, often bringing young members of her family along to learn the language. For years she was a teacher at Cass Tech, a Detroit public high school. She taught fashion design and made art out of gold in her spare time. "Do you still?" we asked. "I don't go near the fire because I can't run fast," she explained.

"Do you want to see the gallery?" she offered. It seemed unthinkable that there might be more.

We walked down the steps of her porch and immediately up the stairs of the house-cum-gallery next door. Arts Extended Groupe was

established in Midtown Detroit in 1950 by Myrtle Hall, along with Dr. Taylor and a group of other artists and teachers. They wanted a space that could serve as an educational tool, not simply catering to the art market, nor to the growing air of elitism infecting the art world. Later, Dr. Taylor moved the space to her neighborhood. We stood underneath a small painting called *Ladies of the Good Dead*, and listened to her describe an old Brazilian tradition of displaying fabrics upon the occasion of somebody's death. It was a way of collecting funds to buy young men out of slavery. The day outside darkened, slipped closer to single digits. We prepared our coats to go.

◆

After we've been on lockdown for a while, I call to find out how Dr. Taylor is faring. She is doing fine, she tells me. She talked to her friends in Italy just last week. There is a woman on staff who goes to the gallery every so often to let in light and water the plants. There is a new show up for no one to see, photorealistic drawings of the tales of Osei Tutu, detailing the founding of Ghana. She is making plans for the gallery's next phase—a turn away from brick and mortar, in the direction of something more like a foundation.

The doorbell rings and she excuses herself. When she gets back on the phone, she says, "You can't see the smile on my face. It's big, I can assure you." Two of her great-grandsons had just come by, and when she got to the door they were standing on the sidewalk, waving. "That was so nice!" Her voice conveys a haze of emotion so palpable it catches in me, too. "The second from the oldest, he calls me on his phone sometimes to tell me he misses me." Their father, her grandson, is a phlebotomist who lives next door, she tells me, and he takes care to strip down and shower when he comes home before greeting his family. As I imagine the scene playing out, I visualize a kind of Charlie Chaplin figure, or a magician. Her tone is so infused with wonder. It takes her a moment to compose herself.

A curator chose a painting from Dr. Taylor's collection to hang at the Detroit Institute of Arts. It's titled *Little Paul*. It is a portrait of her grandson, the phlebotomist, that she commissioned from a little-known painter named Robert L. Tomlin years ago. A boy sits in a chair wearing a gray blazer, jeans, and tennis shoes, gazing intently at the corner of the room. In an article about the exhibition, a curator from the museum muses about the life behind the painting, notes how it intrigues her.

In *The Last Black Man in San Francisco*, the sidewalk preacher shouts, "I urge you. Fight for your land. Fight for your home." The protagonists of the film fly by on a skateboard, passing frozen scenes of Black life, scenes of a city that is disappearing in real time.

I remember, years ago, watching an interview with Kerry James Marshall, in which the painter carefully confronts two white art collectors who have amassed an impressive collection of contemporary Black art, including his own, and exhibited it as part of a highly regarded traveling exhibition. He brings up the fact that no Black art collector could do what they have done. His words are delivered as a statement, but in my mind, they hang in the air like a question.

When I think about the specific importance of a Black art collector, I think about the moment we are living, or not living, through. There are stories inside every Black life lost to the virus in Wayne County. I think of my great-aunt, who, bafflingly, just tested negative, and was released from the hospital last night. I think of Dr. Taylor's attic full of artwork, which remains precious to her whether it falls in or out of fashion. I think about the affection that radiates from her voice. How it lingers. It is infectious.

Bibliography

A Clear Presence

Blumenthal, Max. "How Law Enforcement and Media Covered Up the Plan to Burn Christopher Dorner Alive." *Alternet*, February 2013.

Dorner, Christopher. "Manifesto." KTLA 5 Online, February 2013.

King, Rodney, and Lawrence J. Spagnola. *The Riot Within*. Harper Collins, 2012.

McCartney, Anthony. "Police: Rodney King Death Ruled Accidental." Associated Press, August 2012.

Sloan, Lester. Interview with Sammy Lee, 2004.

Sooke, Alastair. "David Hockney: A Bigger Picture, Royal Academy of Arts, Review." *Telegraph*, January 2012.

Stangos, Nikos. *Paper Pools*. Abrams, 1980.

Sykes, Christopher Simon. *David Hockney: The Biography: 1937–1975: A Rake's Progress*. Nan A. Talese / Doubleday, 2012.

Wallace, B. Alan. *Dreaming Yourself Awake: Lucid Dreaming and Tibetan Dream Yoga for Insight and Transformation*. Shambhala, 2012.

Williams, Juan. *My Soul Looks Back in Wonder: Voices of the Civil Rights Experience*. Sterling, 2004.

Ocean Park #6

Bancroft, Sara. "Video: Sara Bancroft speaks about Richard
Diebenkorn's *Ocean Park* series," June 2011: http://blogs.getty.edu
/pacificstandardtime/explore-the-era/archives/v40/.

Batmanglij, Zal, director. *The East*. Fox Searchlight Pictures, 2013.

Burgard, Timothy Anglin, Steven Nash, and Emma Aker. *Richard
Diebenkorn: The Berkeley Years, 1953–1966*. Yale University Press, 2013.

Carson, Anne. *Decreation: Poetry, Essays, Opera*. Vintage Contemporaries,
2006.

Claudel, Philippe, director. *I've Loved You So Long*. Sony Pictures
Classics, 2008.

Didion, Joan. *Blue Nights*. Knopf, 2011.

Didion, Joan. *The White Album*. Farrar, Straus & Giroux, 2009.

Glass, Philip, Robert Wilson, and Michael Riesman. *Einstein on the
Beach*. New York: Elektra Nonesuch, 1993. Sound recording.

Hiroshima Peace Cultural Center. Testimony of Isao Kita: https://
www.inicom.com/hibakusha/isao.html.

Kimmelman, Michael. "A Life Outside." *New York Times*, September
1992.

Kimmelman, Michael. "Richard Diebenkorn, Lyrical Painter, Dies
at 71." *New York Times*, March 1993.

Larsen, Susan. Interview with Richard Diebenkorn. Smithsonian
Archives of American Art, 1987.

Laurence, William L. "Eyewitness Account of Atomic Bomb
Over Nagasaki." War Department Bureau of Public Relations,
September 1945.

Minghella, Anthony, director. *The English Patient*. Miramax, 1996.

Ondaatje, Michael. *The English Patient*. McClelland & Stewart, 1992.

Silverblatt, Michael. Interview with Joan Didion. KCRW *Bookworm*,
2011.

Tippett, Krista. "Katy Payne—In the Presence of Elephants and
Whale." *On Being*, 2015.

United Press International archives. "Five Lifeguards at Beach Near
Storm Drain Get Cancer." October 1980: https://www.upi.com
/Archives/1980/10/17/Five-lifeguards-at-beach-near-storm-drain
-get-cancer/8414340603200/.

Wikipedia. "Ace of Spades": https://en.wikipedia.org/wiki/Ace_of
_spades.
Wittgenstein, Ludwig. *Remarks on Colour.* University of California
Press, 1978.

Playlist for a Road Trip with Your Father

Diamond, Jared. *Guns, Germs, and Steel: The Fates of Human Societies.*
W. W. Norton, 1997.

How to Teach a Nightmare

Cotter, Holland. "Spectacle for the Heart and Soul." *New York Times*,
August 2007.
Denver, Leela. Journal entry; used with permission.
Gardner, John. *Grendel.* Random House, 1971.
Harrington, Kate. Journal entry; used with permission.
Kinnell, Galway. *The Book of Nightmares.* Houghton Mifflin, 1973.
Kinnell, Galway. "The Bear" from *Three Books.* Houghton Mifflin,
2002.
Mullison, Kara. Journal entry; used with permission.
Pernick, Rachel. Journal entry; used with permission.

D is for the Dance of the Hours

Bendjelloul, Malik, director. *Searching for Sugar Man.* Sony Pictures
Classics, 2012.
CBS Detroit. "Enter at Your Own Risk: Police Union Says 'War-Like'
Detroit Is Unsafe for Visitors." October 2012.
Daily Mail per Associated Press. "Guardians of a broken city: Detroit's
police struggle to make ends meet." February 2014.
Leary, John Patrick. "Detroitism." *Guernica*, January 2011.
Scott, Bruce. "Strife and Salvation: Beethoven's 'Fidelio.'" NPR
World of Opera, January 2011.
Tippett, Krista. "Grace Lee Boggs: A Century in the World." *On Being*,
August 2015.
Warrack, John, and Ewan West. *Concise Oxford Dictionary of Opera.*
Oxford University Press, 1996.

One American Goes to See *30 Americans*

Detroit Institute of Arts. *30 Americans* audio tour. October 2015–
 January 2016.
Rubell Family Collection. *30 Americans: The Conversations.* DVD, 2011.

Dreaming of Ramadi in Detroit

Bergen, Peter. "Secrets of the bin Laden treasure-trove." CNN,
 May 2015.
Da Ali G Show. Season 3, episode 6. HBO, August 2004.
Everett, Percival. *I Am Not Sidney Poitier.* Graywolf Press, 2009.

How to Prepare to See the Royall Family Portrait

Als, Hilton. "The Shadow Act." *New Yorker,* October 2007.
Biss, Eula. *Notes from No Man's Land.* Graywolf Press, 2009.
Cunningham, Valerie, and Mark J. Sammons. *Black Portsmouth: Three
 Centuries of African American Heritage.* University of New Hampshire
 Press, 2004.
Feke, Robert. *Portrait of Isaac Royall and Family,* 1741. Fogg Museum,
 2016.
Kim, Eunsong. "Found, Found, Found, Lived, Lived, Lived." *Scapegoat
 Journal,* 2016.
Krauss, Alison. "Down to the River to Pray." *O Brother, Where Art Thou?*
 2000.
Walters, Wendy S. *Multiply/Divide.* Sarabande Books, 2015.

Gray's Anatomy

Bertoglio, Edo, director. *Downtown 81.* New York Beat Films, 2000.
Clement, Jennifer. *Widow Basquiat: A Love Story.* Broadway Books, 2014.
Hoban, Phoebe. *Basquiat: A Quick Killing in Art.* Penguin, 1999.
Taussig, Michael. *Defacement: Public Secrecy and the Labor of the Negative.*
 Stanford University Press, 1999.
Thompson, Robert Farris. "Royalty, Heroism, and the Streets:
 The Art of Jean-Michel Basquiat." *The Hearing Eye: Jazz and Blues
 Influences in African American Art.* Oxford University Press, 2009.

Caldera

Douglass, Frederick. *Narrative of the Life of Frederick Douglass*. Penguin, 2014.

Lispector, Clarice. *The Passion According to G.H.* New Directions, 1964.

Myles, Eileen. "What I Saw." *The Importance of Being Iceland*. MIT Press, 2009.

That Black Abundance

Laymon, Kiese. *Heavy: An American Memoir*. Scribner, 2018.

Schepisi, Fred, director. *Six Degrees of Separation*. Metro-Goldwyn-Mayer, 1993.

Ladies of the Good Dead

Talbot, Joe, director. *The Last Black Man in San Francisco*. Plan B Entertainment, 2019.

The Ornithologist's Husband Dreams of Annihilation

Casey, Maud. *The Art of Mystery*. Graywolf Press, 2018.

Herzog, Werner, director. *The Cave of Forgotten Dreams*. IFC Films, 2011.

Herzog, Werner, director. *La soufrière*. Werner Herzog Filmproduktion, 1977.

Acknowledgments

Thank you to the readers who saw this book through its various stages of becoming, especially Hannah Ensor, Arianne Zwartjes, Beth Alvarado, Debbie Weingarten, Riley Beck, Lisa O'Neill, Divya Victor, and Gabrielle Civil. Thank you so much to Hillary Brenhouse, Sarah Gzemski, and Joe Quarnberg, for your incredible work polishing the original edition. Thank you to every single person who donated to my Indiegogo fundraiser so that I could work with the phenomenal Kima Jones and Allison Conner at Jack Jones Literary Arts. Thank you to everyone featured in these pages for enduring the loving attention of a nonfiction writer.

Thank you to Leela Denver, Rachel Pernick, Kathleen Harrington, Kara Mullison, Khánh San Pham, Jillian Walker, Avery Friedman, Liz González, Cam Flynn, Kristen Nelson, TC Tolbert, Frankie Rollins, Samiya Bashir, Brian Blanchfield, Eunsong Kim, Gelare Khoshgozaran, Wendy S. Walters, Beth Staples, Emily Smith, Anna Lena Phillips, Paula Mendoza, Michael Archer, Jeremy Mulligan, Lisa Sloan, Rachel Kincaid, Riese Bernard, Laneia Jones, Heather Hogan, Simmons Buntin, Vanessa Nickerson, Richard Shelton, Allison Hawthorne Deming, Tyler Meier, Renee Angle, Katherine A. Smith, L. A. Sabatini, Phil Iosca, Juliette McGrew, Cora Mae

Andrews, Angelina Burnett, Ladan Osman, Victoria Garza, Jennifer Fisher, Pamela Russell, Stef Willen, Susan Jaret McKinstry, Brigitte Lewis, Shannon Harwood, Marie Louise Keen, Sara Jane Stoner, Maya West, Aric Knuth, Tisa Bryant, Ander Monson, Laura Wetherington, Shira Dentz, Lisa Strid, Joy and Doug Ensor, Rosa Boshier, Marie-Helene Bertino, and Ruth Curry for great editing, inspiration, support, and guidance. Thank you to Lester Sloan and Lorraine Sabatini for everything, always. And so much gratitude to Hannah, my love, for patiently listening to me read every single essay out loud about fifteen times apiece.

Essays in this book originally appeared in the following publications: *Guernica* published "A Clear Presence" and "How to Teach a Nightmare." "Playlist for a Road Trip with Your Father" and "One American Goes to See *30 Americans*" were published on *Autostraddle*. "D Is for the Dance of the Hours" appeared in *Ecotone* and, in excerpted form, on *Catapult*. "*Ocean Park #6*" was published by the *Sierra Nevada Review*. "Dreaming of Ramadi in Detroit" appeared in the *Offing*. "How to Prepare to See the Royall Family Portrait" was published by *Contemptorary*. "Caldera" was published in *Sublevel*. "That Black Abundance" originally appeared in *American Book Review*. "The Ornithologist's Husband Dreams of Annihilation" originally appeared in the *Los Angeles Review of Books*. "*Ladies of the Good Dead*" originally appeared in the *Paris Review* online. Thank you so much to Sandra and Ben Doller, Adam Stutz, Adam Bishop, Biswamit Dwibedy, Brianna Johnson, Emily Mernin, Yesenia Padilla, and Leslie Patron at 1913 Press. And thank you to Maggie Nelson for choosing this book as the winner of the Open Prose Book Prize; what a dream come true.

Such deep thanks to PJ Mark and Kerry-Ann Bentley at Janklow & Nesbit for championing this book's second life. And my endless thanks to Ethan Nosowsky, Anni Liu, Katie Dublinski, Carmen Giménez, and the entire team at Graywolf for bringing it back into the world.

Aisha Sabatini Sloan was born in Los Angeles. She is the author of *The Fluency of Light, Dreaming of Ramadi in Detroit, Borealis,* and *Captioning the Archives.* She is the winner of the CLMP Firecracker Award, the 1913 Open Prose Contest, the National Magazine Award for Columns and Commentary, the Jean Córdova prize for Lesbian/Queer Nonfiction, the Lambda Literary Awards for Bisexual Nonfiction, and a National Endowment for the Arts fellowship. Her essays can be found in *Ecotone, Ninth Letter, Callaloo, Autostraddle, Guernica,* the *Paris Review,* the *New York Times, Gulf Coast,* and the *Yale Review,* among other places. She is an assistant professor of English at the University of Michigan.

The text of *Dreaming of Ramadi in Detroit* is set in Baskerville URW.
Book design by Rachel Holscher.
Composition by Bookmobile Design & Digital
Publisher Services, Minneapolis, Minnesota.
Manufactured by Versa Press on acid-free,
30 percent postconsumer wastepaper.